IMAGES
of America

UNION

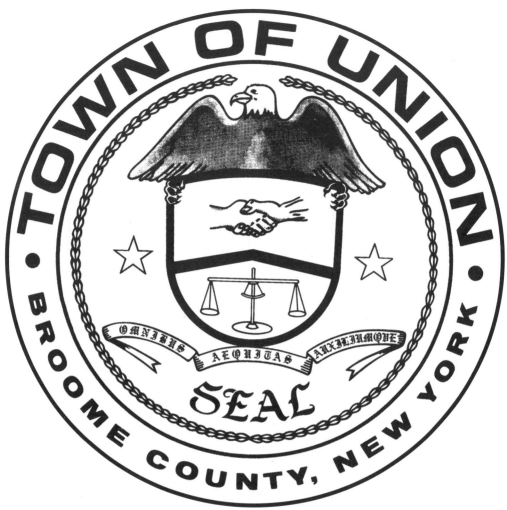

The Town of Union Seal incorporates symbols of cooperation, justice, and pride in America.

IMAGES of America
UNION

Suzanne M. Meredith

Copyright © 1999 by Suzanne M. Meredith.
ISBN 0-7385-0329-0

Published by Arcadia Publishing,
an imprint of Tempus Publishing, Inc.
2 Cumberland Street
Charleston, SC 29401

Printed in Great Britain.

Library of Congress Catalog Card Number: Applied for.

For all general information contact Arcadia Publishing at:
Telephone 843-853-2070
Fax 843-853-0044
E-Mail arcadia@charleston.net

For customer service and orders:
Toll-Free 1-888-313-BOOK

Visit us on the internet at http://www.arcadiaimages.com

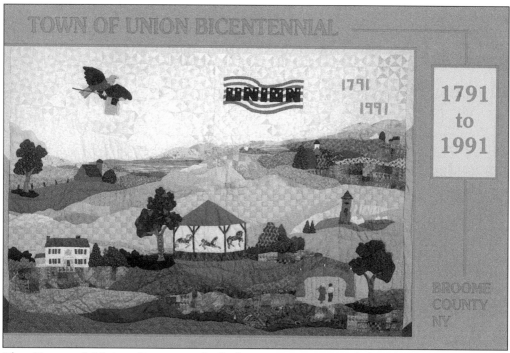

The Town of Union Bicentennial Quilt was commissioned by the Endwell League of Community Action, a local service organization. Ethel Whittemore, a member of ELOCA, designed and crafted the quilt. Many significant town landmarks and events are chronicled in the pattern. The quilt was presented to the Town of Union and currently hangs in the Town boardroom.

Contents

Acknowledgments — 6

Introduction — 7

1. The Early Days — 9
2. Life and Progress — 43
3. Labor, Leisure, and Landmarks — 51

ACKNOWLEDGMENTS

Appreciation is expressed to the following people and organizations for their gracious assistance in producing this volume. Without their gift of information, time, and the loan of photographs, the book could not have been completed:

Jack Cheevers—Town of Union Supervisor
Town of Union Council members: Michael Archangeli, Donald B. Battaglini, Francis
　McManamon, Rose Sotak
Jacqueline Tedesco—Deputy Town of Union Historian
Alex Alexander
The Amos Patterson Museum
Ed Aswad—Photographer
BC Charities
Betty Bartlow—Vestal Historian
Jane Beaver—Vestal Museum Curator
Dorn Black
Broome County Historical Society
The Consol Family
Joanne Grassi Florini
Grace Ireland—Amos Patterson Museum Treasurer
Rich Knight—IBM Community Relations
Janet Ottman—Village of Johnson City Historian
The Rounds Family
Gerald Smith—Broome County Historian
Joan Sacco
The Vestal Historical Society
R. Ted Warner—Village of Endicott Historian
Ralph Warner—Old Union Historical Society
Don Wunder

INTRODUCTION

TOWN OF UNION

In the beginning the Town of Union included over 700 square miles in the glaciated Allegheny Plateau. Much of the land spread along the Susquehanna River Valley, a vale about nine miles long and averaging two miles in width. It is an area embraced by the presence of towering green foothills of the Catskill Mountain range. The population has learned to appreciate the forests and meadows of the hills, often building homes and farms on the rock strewn inclines.

The original land patent was obtained by General Oringle Stoddard, who came from Massachusetts in 1785 as a commissioner for the Boston Company to bargain with the Native Americans for land. An enormous tract, 2,300,000 acres, changed hands, and became known as the Boston Purchase. The price agreed to was 12 1/2¢ per acre. Half of this amount was to be paid in cash, and the rest in trade goods. Land was apportioned to the 60 investors according to the amount each individual had contributed to the corporation. Union was formed on February 16, 1791, as part of the County of Tioga, by an act of the New York State Legislature, and later became one of the original towns of Broome County.

The vicinity of Union was the homeland of the Iroquois for many generations until the 1780s when trappers, traders, and settlers from Europe began to carve pathways to the future. By 1791, there were 600 pioneer residents, and the native people began to disappear. Travel was mainly on the river, and over faint Native American trails along the banks. The barter system prevailed in the fledgling economy, with hides, tallow, ashes, and grain accepted in place of cash, and shillings were used more often than dollars well into the 1800s. Eventually, commerce changed from farming, fishing, and lumbering to shops and factories, and on to technologically sophisticated empires.

Early residents dreamed of one continuous city along the valley floor from Port Dickinson to the Tioga line. Although an amalgamation of municipalities has yet to evolve, the lives of the people flourish, and boundaries blur, as population and cultures entwine to create an exciting and diverse community—a Union, of spirit, fortitude, and faith in America.

The photographs presented are whispers from the past . . . dating from approximately 1880 to the 1940s . . . honoring our heritage, and the values and faces of the people at labor and leisure.

Many significant landmarks have been included in the collection of images—and I realize there are numerous subjects, people, and places may not be part of this book—but we are limited to the photographs available and space constraints. So if something is missing, send me a photo and it will be in any future edition.

Suzanne M. Meredith, Historian, Town of Union

Village of Johnson City

The village of Johnson City is a living memorial to George F. Johnson (GFJ). An employee of the Lester Brothers Boot and Shoe Company of Binghamton, Johnson is given credit for suggesting the site for a new factory a few miles west of Binghamton. The Lester Brothers acquired enough acreage to map out streets and sell lots for homes. In 1890, they built the Pioneer Factory and a community rapidly blossomed around it. On September 15, 1892, it was incorporated as the Village of Lestershire.

Innovative manufacturing ideas earned G.F. Johnson the position of supervisor of the company, and in 1899, he purchased a half interest in the concern from its major stockholder, Henry B. Endicott. The Endicott-Johnson Shoe Company enjoyed many years of prosperity, which it shared with the employees. These programs were part of GFJ's concept of an industrial democracy that he called "The Square Deal Policy." In addition to employee benefits, G.F. Johnson donated an estimated $15 million in parks, swimming pools, merry-go-rounds, a golf course, and public libraries for the use of everyone in the community. The citizens of Lestershire voted to change the name of the village to Johnson City in 1916, to honor its greatest benefactor.

Examining historic photographs and documents prompts reflection on the people and events that influenced the development of our area. Early immigration from many Eastern European countries, and recently from Southeast Asia, has added to the rich cultural heritage of our community. Often these people arrived in America knowing only how to ask, "Which way to EJ?" Their tangible legacy in the form of monuments and memorials is evident. No less important are the verbal links to our past that can be found in stories passed down through the generations, this gives life to the chronicle of Johnson City.

<div style="text-align: right">Janet Ottman, Historian, Village of Johnson City</div>

Village of Endicott

John and Joshua Mersereau, two early settlers, arrived in 1785 homesteading on the west side of the current Village of Endicott. The area incorporated in 1871 as the Village of Union. One mile east of the Village of Union was a dairy farm on the banks of the Susquehanna River. George F. Johnson, half owner of the Lestershire Shoe Company in Lestershire (now called Johnson City), bought 200 acres in the area and declared it the site for new factory buildings and a new town. Endicott-Johnson (EJ) eventually became the largest shoe company in the world, employing 20,000 workers. It provided them with every benefit imaginable, including houses sold at cost, free medical care, a revolutionary eight-hour workday, and a golf course.

In 1906, the Village of Endicott was incorporated, and in 1921, Union and Endicott merged into one village. George F. Johnson gave a total of six carousels to the Triple Cities, four of which are in the Town of Union. With only 200 operating merry-go-rounds in the nation, it is easy to see why Endicott is considered the "Carousel Capital of the U.S."

Endicott is also the birthplace of International Business Machine (IBM) and the computer. Thomas J. Watson Sr. gradually developed IBM from its early beginnings in Endicott into the largest corporation (of any kind) in the world. Today's championship En Joie golf course, built by G.F. Johnson, is home to the BC Open, a professional stop on the PGA tour. The tournament was named after the BC cartoon strip written by Endicott native John Hart. En Joie is one of only three PGA tournament courses in the world still open to the public. A new Visitor Center in Endicott is preserving Historic evidence of the village past and promoting its promising future.

<div style="text-align: right">R. Ted Warner, Historian, Village of Endicott</div>

One
THE EARLY DAYS

From the Minutes of the First Meeting of the Town of Union
February 16, 1791

PURSUANT TO THE LAW OF THE STATE OF NEW YORK – PASSED ON THE SIXTEENTH DAY OF FEBRUARY in the Year of our Lord one thousand seven hundred & ninety-one for the purpose of having a Town meeting in the Town of Union. The said bounds of said town are as follows: Beginning south on the Pennsylvania Line, Westerly by the Town of Owego, Northward to the bounds of the County of Tioga - Easterly by the River Chenango and Susquehanna - Said meeting being held at the home of Nehemiah Spaulding on the first Tuesday in April one thousand seven hundred & ninety-one. The following persons were chosen to the several offices announced names:

Silas Hutchenson – Town Clerk

Joshua Whitney – Supervisor

Assessora – Daniel Seymour – Silas Hutchenson – William Bates

Poormasters – James Lyon – Silas Gaskill

Commissioners of Highways –
Amaziah Hutchenson – William Whitney – Hathan Howard – William Bates – Amos Draper

Justice of the Peace – David Hilton – Daniel Reyla – Oringah Stoddard – James Lyon – Ebinizer Green
Daniel Hudson – Joseph Leonard – Joh Harvy

Voted in the Town meeting that the Commissioners of Highways shall regulate the Ferreys in this Town

Election held on the last Tuesday in April according to Law at the home of Nehemiah Spaulding – the poll left open four days, being adjourned from place to place, but closed the Poll at the House where it was opened agreeable to readvertisement.

The Inspectors of Elections –
Jashua Whitney 2 days – Daniel Hutchenson 4 da, – Daniel Seymour 4 da. – William Bates 2 da.

Highways Layed out for the Town of Union in the County of Tioga, State of New York, by the Commissioners of said Town which as follows: beginning at a White Oak tree standing on the west side of the Chenango River, in what was formerly called the Chenango Town; a public Highway beginning at the Mill Standing on what is called Castle Creek; a Highway beginning at the west bank of the Chenango River at the Southeast corner of Joshua Whitney & Northeast corner of the Whitney's Lots.

The undersigned, Town Clerk of the Town of Union, certifies that the within Minutes have been compared by the undersigned with the original and found to be a true copy.
August 1, 1999

Gail L. Springer
GAIL L. SPRINGER
Town Clerk, Town of Union

Minutes from the first meetings of the Town of Union have been carefully preserved for more than two hundred years.

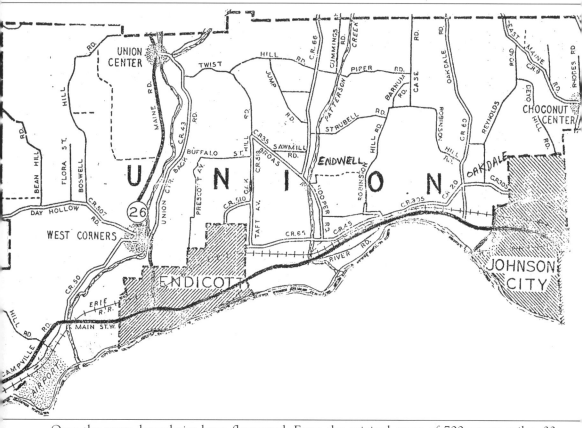

Over the years, boundaries have fluctuated. From the original grant of 700 square miles, 33 square miles remain in Union. It includes two incorporated villages, Johnson City and Endicott, and dozens of titled neighborhoods and hamlets. With a population of over 60,000, Union is still one of the largest towns in the state of New York.

Anne Williams Patterson, 1753–1815, was one of the earliest settlers in the Town of Union. She married Amos Patterson in 1775, who was a member of the original Boston Purchase group. He arrived in Union in 1786, spending only summers in the area, until 1791 when he cleared land for a farm and sent for his family in Boston. Anne responded by loading possessions and children into wagon and successfully navigating her oxen team to their new home in New York State. For a few years, home was a log cabin, but in 1799, Amos built a magnificent home on the banks of the Susquehanna River, Washingtonian Hall. Anne bore 12 children, two of whom died tragically. Little Amos fell into the river and was lost, and one year later, his four-year-old sister fell into a vat of tallow that had been simmering in the yard. Other Patterson children carried on the family name and heritage of serving the community.

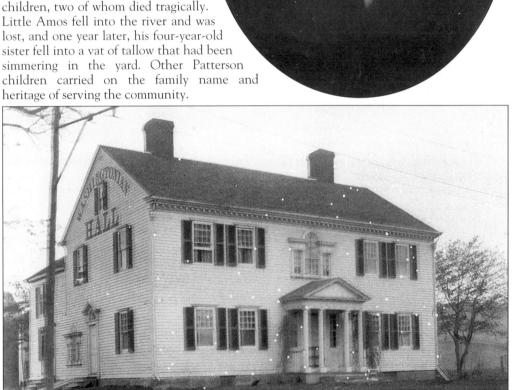

Washingtonian Hall was built in 1799 without the use of any nails. It is completely fashioned with wooden pegs. The "Washingtonian Hall" designation was painted on both sides of the building in 1842 by John Sayre, who purchased the home in 1830 for use as the first temperance tavern in the United States. A branch of a nationwide temperance society, the Washingtonians met regularly at the inn. The home is still standing, and has recently been added to the National register of Historic Homes.

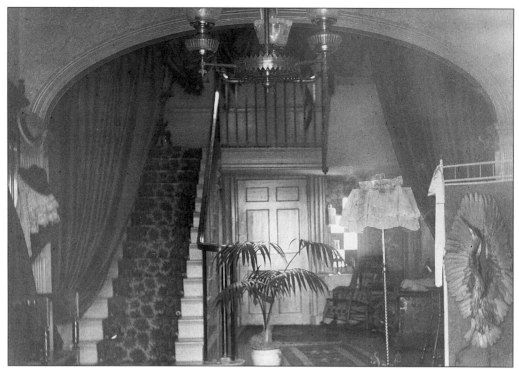

The main staircase and entry to Washingtonian Hall has changed very little from the time of this photograph taken in 1900.

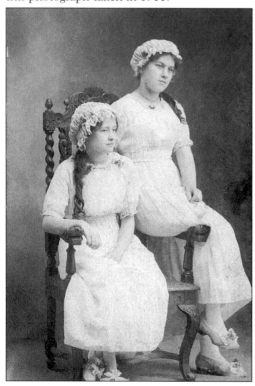

Classic headwear for women working in and around the house was mobcaps. These two young ladies are wearing a fancier version. The year is approximately 1899.

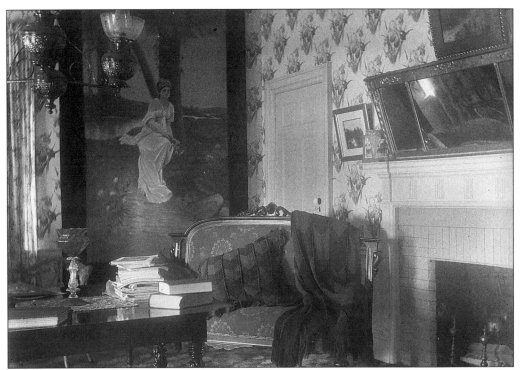

This photograph is made from a glass negative taken about 1900. It was identified as the interior of Washington Hall by the large tapestry hanging on the back wall. As the home was sold, each time the tapestry was entrusted to the new owner. No one wished to remove the tapestry lady from her home, and today it still hangs on the historic walls.

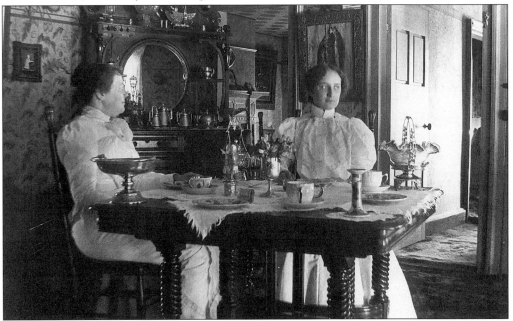

An obviously boisterous tea party was held in the dining room of Washingtonian Hall in 1900. The delicate white dresses set off lustrous dark woodwork.

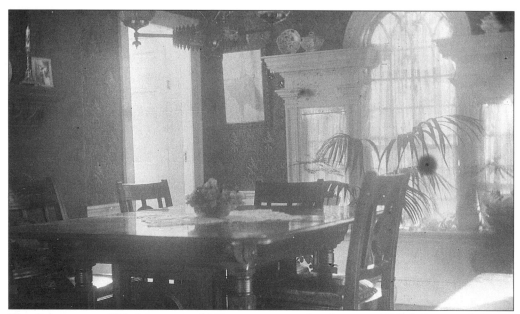

The dining room of Washingtonian Hall was constructed with a graceful Paladian window, one of two in the building. Architecture, art, and history students, and admirers of fine craftsmanship spend considerable time admiring the details of the woodworker's art.

In 1791, what is believed to be the oldest church in Broome County, the Dutch Reformed Church, existed in the Township of Union. Original records have been lost, but it is known to have stood in the old Union district of Endicott, in the rear of what is now Riverside cemetery on the highest knoll in the section. It had a 360-degree view of the area. It was a crude building, constructed of rough-hewn logs with slabs of wood for pews set on an earthen floor. The two shillings an acre paid for the land was considered a sound investment in morality and godliness. In 1803, the people believed a place to worship was so important that they appropriated $25.00 a year from the town treasury to help support the church. The log edifice remained standing until 1822.

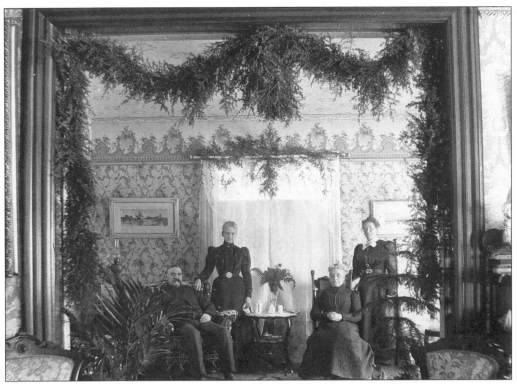

This image showcases a home and household decorated for Christmas, c. 1900.

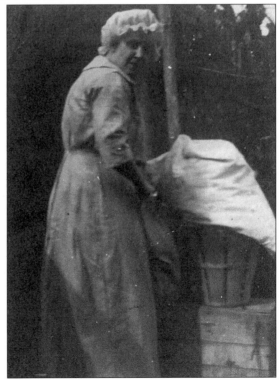

Etta Mae Rose is garbed in the everyday work attire of a homemaker, a mobcap and apron, getting ready to can apples in 1898.

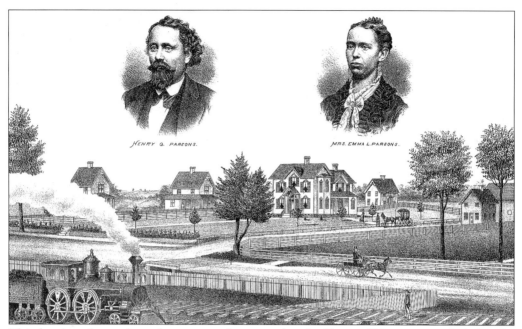

This drawing of an early, and prosperous, homestead in the Town of Union was included in the 1876 *Historical Atlas of Broome County Illustrated*.

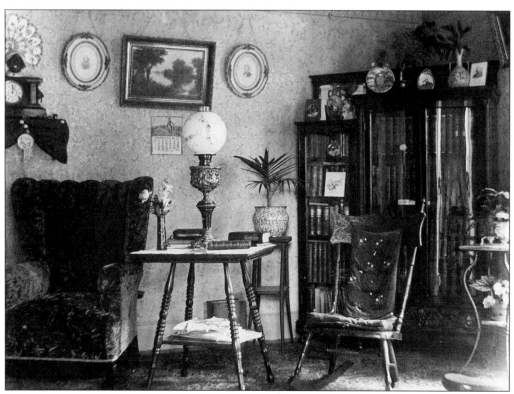

The above photo was produced from a glass negative and shows a typical room arrangement in an early-20th-century home.

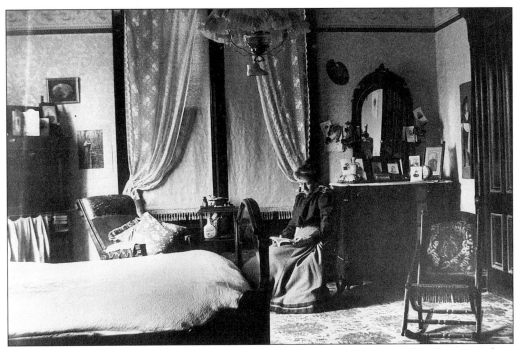

A quiet corner in a lady's bedroom was set aside for an opportunity to read and contemplate, c. 1905.

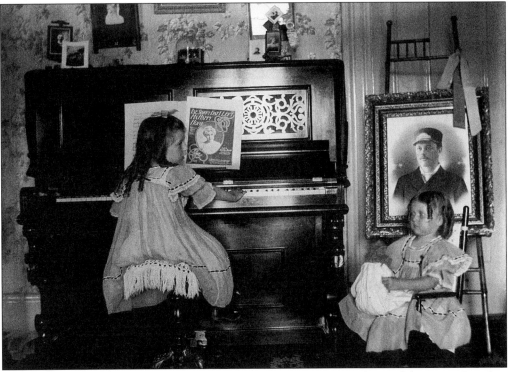

Music and sewing were appropriate pastimes for little girls, wearing identical dresses and ringlets in their hair, c. 1910.

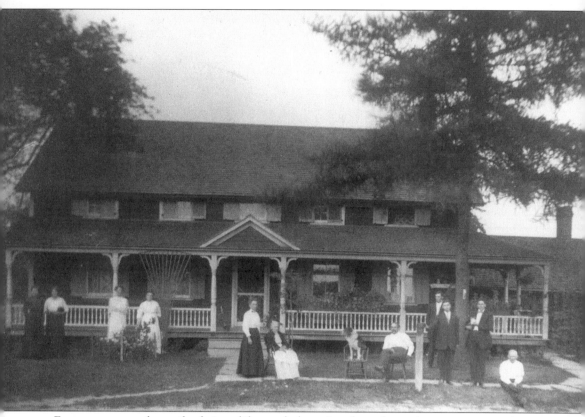

For a moment, the veil of time lifts, and the misty boundaries between past and present disappear . . . through a poignant memoir history becomes reality.

One picture may be worth a thousand words, but in this instance a slim journal of a thousand words paints a portrait, of life in the Town of Union from 1852 through 1856. Maria is 40 years old as the account begins, and it is her tenth year as wife to Isaac. Her first husband and two-year-old daughter had been lost to "grippe." They are living on a 180-acre farm, in a spacious homestead with her in-laws, Peter and Phoebe. The building was erected in 1822 and is large enough to accommodate three generations of family comfortably. Local forests provided the hand-hewn timbers for walls, shingles, and much of the furniture. Two huge barrels sit outside the back door, both carved from the trunks of massive buttonball trees. These containers predate the house by many decades, and were said to be aged even when in use at the original family cabin that was built in 1816. At the end of each Sabbath, Maria makes notes in her diary, recording special events, feelings, and often a critique of the day's sermon. She writes that the "game is plentiful, the land fertile." Many are her references to a life filled with "perplexities and spiritual challenges." She mentions Isaac as her "friend for life," and comments on missing him when he is away from the farm for even a few days.

January 1, 1852—"I feel quite deprest both in body and mind but enjoy a degree of spiritual feeling."

March 14, 1852—"Attend Mr. Masons metin to day . . . rainy day . . . I am glad that religion will bore us up a midst all worldly afliction that we do have."

March 28, 1852—"Staid clost to home all day went & got sasaphras for Cathran." (*Sassafras was an herbal remedy, also used to make root beer.*)

April 10, 1852—"Satterday went to Alyvans to eat (maple) shugar . . . took the whole family along."

August 14, 1852—"Went to hear Mr. Welton preach a first rate one at the school house and then down to the river in the afternoon and saw two baptised. Joined the church."

As a Quaker, Maria's faith was great, and at times her only comfort came from a belief in the hereafter, but it could not completely ward off depression and loneliness. By November it is obvious that her scant social life is being curtailed by pregnancy.

November 14, 1952—"Staid at home . . . very stormy to day . . . snow . . . a long lonesome day."

January 1, 1853—"Commence a new year at home . . . rather disconsolate."

April 22, 1853—"Our babes ware born this mornin . . . Friday four o'clock" (*Twin boys, Albert and John*).

June 10, 1853—"Went over the crik on a visit saterday . . . bees swarmed."

June 26, 1853—"At home all day taking care of ill babes . . ."

September 29, 1853—Went over to Centerville to have one dergatipe taken . . . mine & Isaac & harriet & the twin boys . . . Mr. Bostick the daugerotipe man."

November 22, 1853—"got a few chesnuts today, John was taken sick . . . sore throght . . . then Albert sick.

November 24, 1853—"Today little Albert died and was burried . . . little Alison sick . . . John very sick today . . . we dont know how it will terminate with him."

December 9, 1853—"John died Friday 20 minits past 4 in the mornin . . . was buried on the sabbath . . . it is truly a sollom time with me . . . my children is gone."

December 20, 1853—"Olova Twining died . . . Mr. Woodhull preched . . . 7 mor died with the same complant."

December 25, 1853—"At home . . . went to the burrying ground . . . not a very merry chrismaz."

Many of her entries hereafter concentrated on local illness and death. Trips to the family "burrying ground" became frequent.

March 15, 1854—"Gilbort Waterman child died with the canker."

March 20, 1854—"The smoke house took fire today and burnt up all our meat as well as our neighbors."

January 30, 1855—"At home today . . . the crazy woman here to visit . . . snowy."

October 1855—"Mr. Sayres cut his own throat today."

December 23, 1855—"At home . . . mother quite smart (well) . . . James very sick with the billows fever . . . we are quite alarmed about him but are in hope."

In 1856 Maria traveled to visit relatives, her mother came to stay often, and the depression seemed to lift occasionally, but as 1856 ended Maria wrote the final entry in her diary . . .

"I am drawing to the close of life . . . soon those that know me will see me here no more on these shores of time but I will be numbered among the dead."

In spite of this dire prediction Maria lived another 47 years, and no other diary has been located. Through the fragile yellowed pages Maria wove a chain, linking her day with ours . . . emotions transcending the ages.

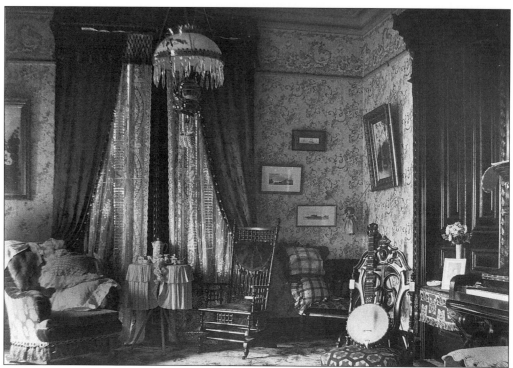

Music rooms were common in above-average family homes. This image is from the early 1900s.

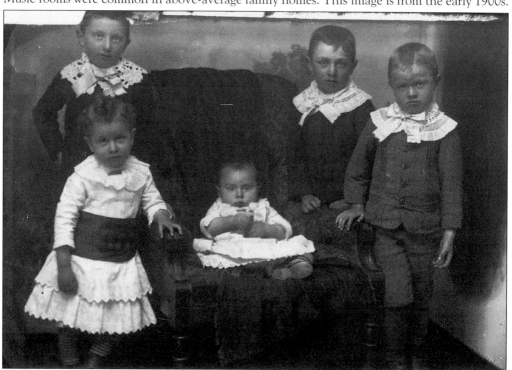

These five happy children are not exactly posed for fun in 1890. Gender was hard to determine, as baby boys were restricted to skirts and dresses until a suitable older age.

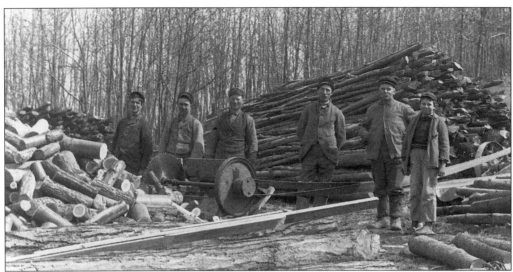

Legends claim that on overcast days travelers needed lanterns to traverse the thick forests of virgin hardwood, oak, and pine. Eventually, the need for tillable fields and clearings for homesteads initiated a local lumbering industry that lasted many decades. The forests seemed endless, and loggers set up camps to harvest the salable lumber. These camps became increasingly remote as the forests were depleted. Mills were established in hundreds of locations, and streams and rivers became the preferred method of transport for floating the logs to mill and market. A man who was knowledgeable in the craft of stump pulling was in great demand. For most of the 1800s, logging remained profitable. Eventually the local ecology changed and adapted to accommodate the newest inhabitants. Dairy farms and cornfields replaced forest and game. This logging camp is typical of the industry as it moved through the forest, harvesting and burning.

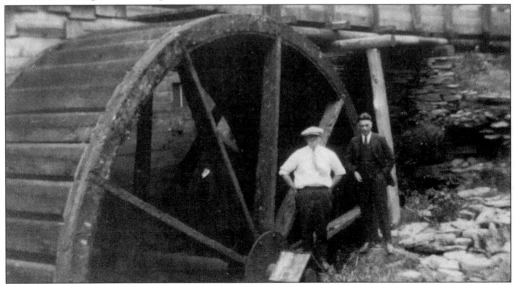

In the mid 1850s, the Bigler steam mill operated in Oakdale, on the corner of what is now Harry L. Drive and Reynolds Road. The hamlet was at that time called Steam Mill, and incorporated a dozen or so houses built for the mill workers. Today the area is better known for malls and shopping plazas.

This little boy had his photo taken in the Town of Union in 1899. He is probably wearing attic attire — parts of an old uniform rescued from the dust for a play or celebration. This image was printed from a glass negative.

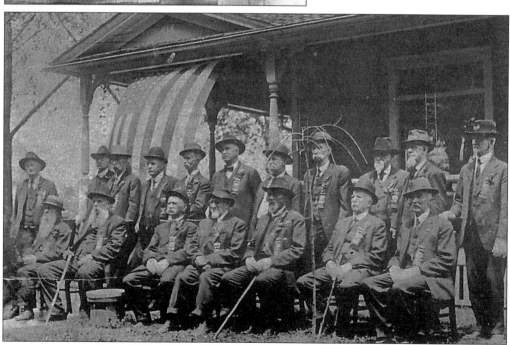

A page in the *EJ Workers Review* of 1919 honored this group from the Union Post of Civil War Veterans. Endicott Historian Ted Warner was able to identify his ancestor Job Mersereau Warner as the seated gentleman in the first row, second from the right.

The only sure outcome of war is death, and the memories that may guide mankind to a better future. The following poem is in tribute to all fallen soldiers.

*Through every nation and every land
A soldier believes that he alone
has the Flag and Father on his side
In every village and every town . . . stand
Pillars of steel, marble and stone
To honor all . . . who served . . . and all who died*

In the Town of Union, an official, detailed register of those eligible for military duty in the Civil War has been preserved. Age, occupation, and status for service are noted. Some of the more interesting occupations like *leacher*, *pedlar*, loafer, Gent, and stump puller, joined the numerous farmers, and "hands." Many were the reasons for exemption, including fever sore, *breach*, *deef*, no thumb, and inferior.

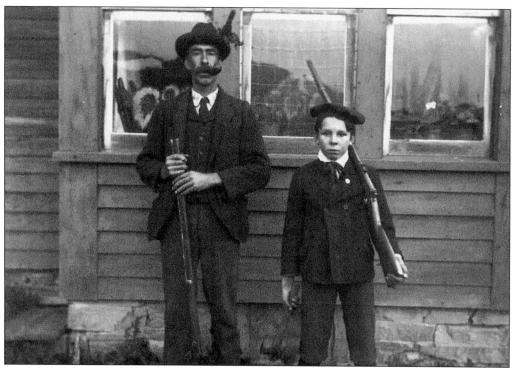

In the days of the pioneer, the second amendment right "to bear arms" had a simpler meaning — a long rifle and a hatchet — as this photograph of a 1909 father and son illustrates.

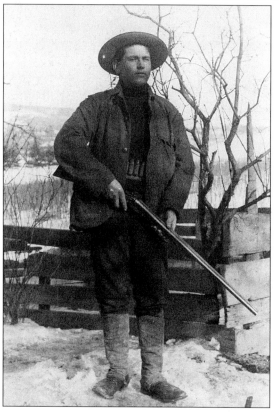

Mr. Gates is the photographer who took some of the photographs in this book. His own image was captured on a glass negative, and considerately labeled. In this instance, he was on a shooting expedition with more than a camera, in approximately 1909.

World War I, "The War to End All Wars," 1914–1918, the most extensive conflict the world had ever seen, filled the hearts and minds of Union residents with fear and patriotism. For the first time chemical, mechanical, and air power was used to wield "the sword of peace." Global revulsion at the thoughts of any future war prompted the creation of the League of Nations.

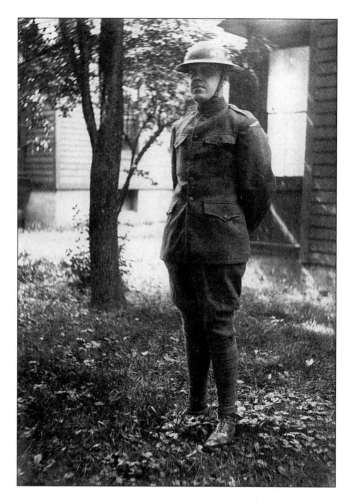

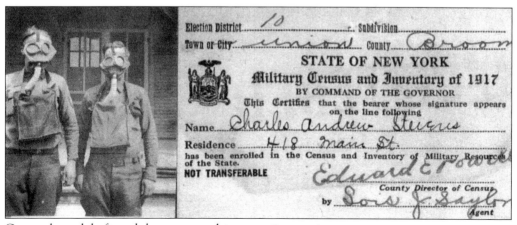

Gas masks and draft cards became mandatory wartime equipment.

Patriotic melodies, rationing, flying flags, and bond drives were common to both the World Wars.

This boy is lending his life, at awful risk, to fight your fight.

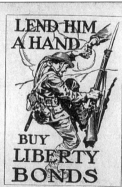

LEND HIM A HAND

BUY LIBERTY BONDS

Won't you lend him a hand, with no risk, and help save his life?

Every Liberty Bond Bought Over Here, Saves Lives "Over There"

HERE he is, the representative of awakened, fighting America, going over the top to help make the world safe for us to live in.

He is risking his life for you and America. Stand behind him. Lend him a hand. The Liberty Loan is *your* chance. It is your share in the Victory that America must win.

Buy all the bonds you can. Liberty Bonds save lives—the lives of our own sons

LIBERTY LOAN COMMITTEE
Second Federal Reserve District
120 Broadway, New York

Victory Begins At Home!

RECIPES
TO MATCH YOUR
SUGAR RATION

DISTRIBUTED TO HOME VOLUNTEERS THROUGH YOUR GAS COMPANY IN THE INTEREST OF NATIONAL CONSERVATION

Reprinted by Sersel, Inc., through Courtesy of the Consumer Division, Office of Price Administration, Washington, D.C.

Sugar rationing is here!

For most of us it will mean little change in eating habits.

For others it will mean cutting down on those sweets that food experts say aren't too good for us anyway.

It is going to mean more fruit desserts. Use fresh fruits liberally in place of desserts that call for sugar. Dried fruits are rich in sugar and can be used to

By 1939, a second World War loomed, stemming from the Great Depression of the 1930s, and from the aggression and persecution tactics of countries who forgot the lessons buried in cemeteries around the world. Union residents again responded by giving lives and lucre. Marshaling our resources, every bond drive went over the need; our women and men served with distinction, both home and abroad, and technology changed fighting fields and homes forever.

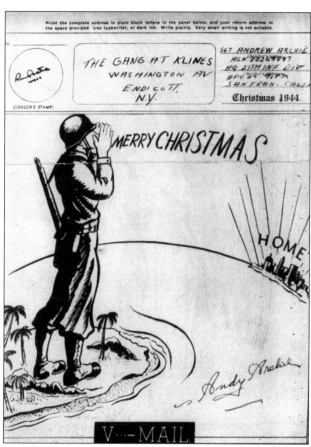

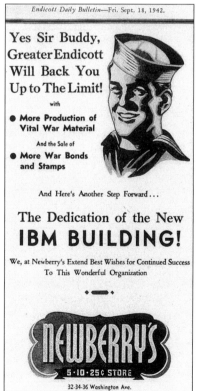

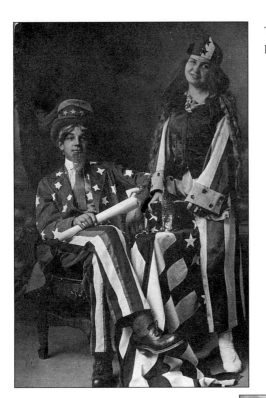

The Stars and Stripes were used to drape young players in a patriotic presentation in 1905.

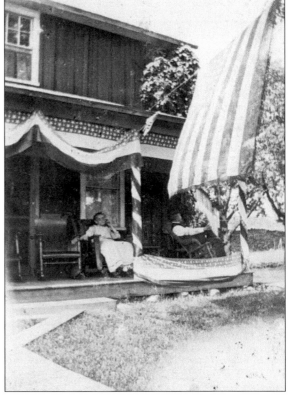

Years ago, patriotism was part of everyone's life, and the Fourth of July was the perfect time to express pride in the United States. Homes were often decked in bunting as well as flags of various sizes. This Union home looked typical for this great day of celebrating freedom.

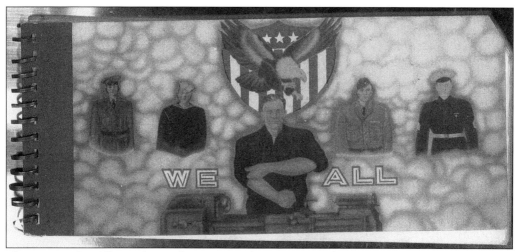

The motto "We All Resolve to do Our Fair Share" was used by IBM during WW II on posters, newsletters, and on this cover of a booklet for customer engineers graduating from the company school in 1944. The booklet was made on tabulating cards.

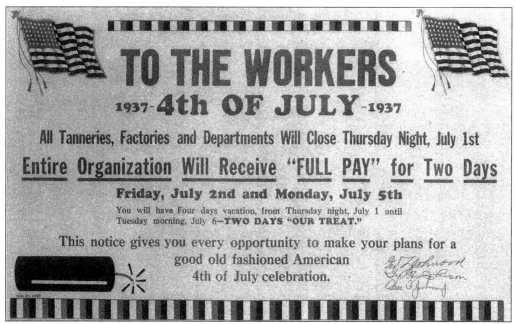

In war or peace, the celebration of life in the land of the free was recognized, and encouraged with time off from work and full pay at EJ, in 1937.

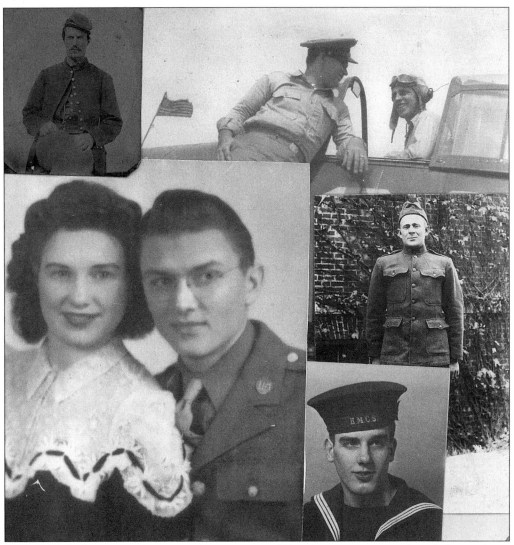

Area residents have served in every American war. The above patriots are, from left to right in the top row, as follows: A tintype of Sidney Rose in his Civil War uniform; Lieutenant J.G. Ralph Warner, pilot and Endicott native during WW II, being greeted by another service man from his home town, Chief Machinist Mate Dino Santacrose. In the center row, far right, is C.V. Biddle of Endwell, a WW I veteran. From left to right in the lower are: Evelyn Robenolt, who worked in a local defense plant as a "Rosie the Riviter" during WW II, with her husband Leonard Robenolt who served in the Philippine Islands; and longtime Town of Union resident Leonard Ireland, who served in the allied forces of the Canadian Navy in 1943.

Dedicated in August of 1947, this monument is constructed of Imperial Danby Marble. IBM located this symbol of sacrifice and freedom on the grounds of the IBM Country Club on Watson Boulevard in Endwell. On its base are listed four freedoms: freedom of religion, speech, freedom from want, and freedom from fear. The names of IBM employees who died in service to their country during WW II are inscribed, along with emblems of remembrance, and an eternal light.

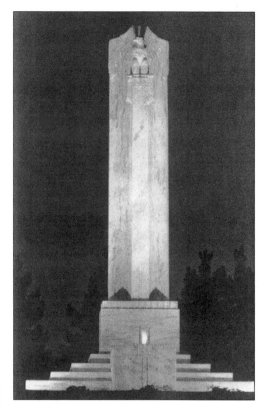

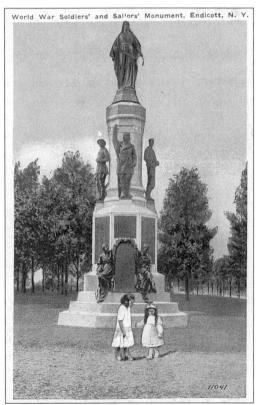

In what has now become a veteran's memorial park in Endicott, the first monument to be erected was in 1922 as a tribute to people who served in WW I from the Endicott Johnson families. The top of the statue is a figure of a Red Cross nurse. Since then, memorials have been placed to honor all of the Town of Union service people in all conflicts.

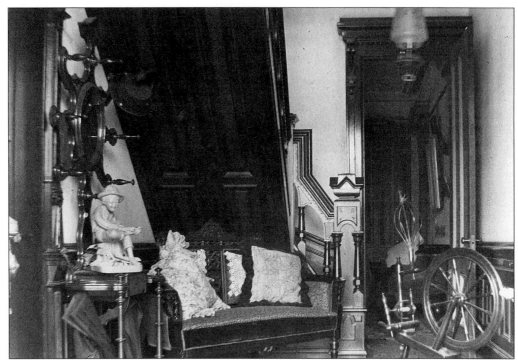

The early history of spinning has been lost to the annals of antiquity, but the need for fiber threads and yarn has for eons been a household industry. In the Victorian entry, above, the spinning wheel was obviously a decoration, but the photograph below shows the reality of necessity, just a few decades previously. In the days of responsibility for the extended family, an unmarried female relative who resided with a family often had the duty of spinning, thus the origin of the term "spinster."

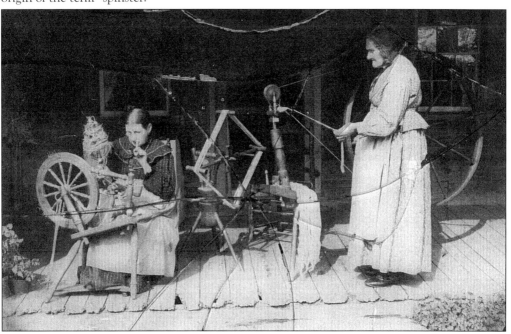

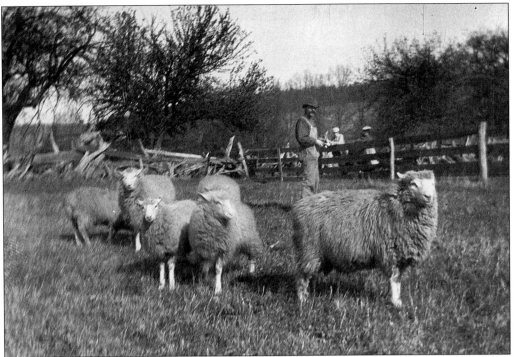

Early in the town's history, Union sheep farming was a profitable venture. Note the stump fence in the left background. Often when a stump puller finished the task of clearing fields of the unwanted protrusions, the stumps would be used to build nearly impenetrable fences around the stock pens. Especially at dusk the twined stumps and wooden tendrils seemed to reach for intruders, presenting a frightening barrier to both man and beast.

Predators were always a problem, and bounties were paid on wild carnivores. In this instance, the Town Dog Fund reimbursed a farmer for damages to his sheep from a pack of dogs.

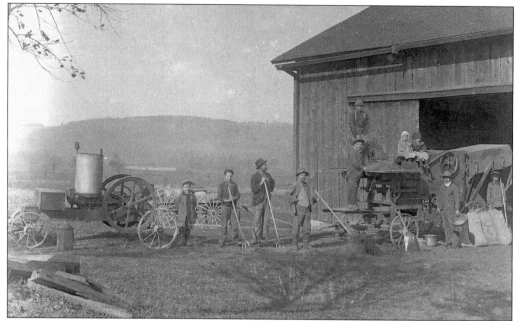

Turn-of-the-century farmers thrashed with the most modern equipment, and used the old standby, pitchforks. Thrashers were often an itinerant group traveling from farm to farm at harvest time.

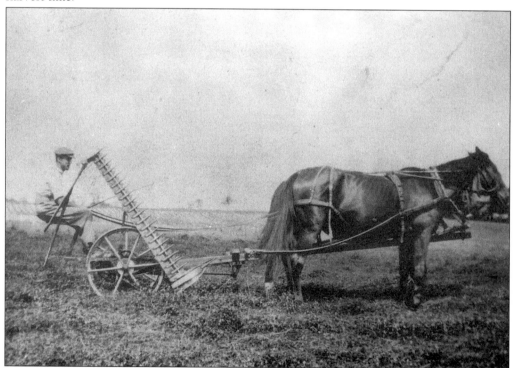

In 1900, man and beast worked together to provide sustenance for both. Marcus Wright is pictured farming the land he was born on in 1888. He lived until 1957 on the farm located near what is now Oakdale Road and Town Line Road.

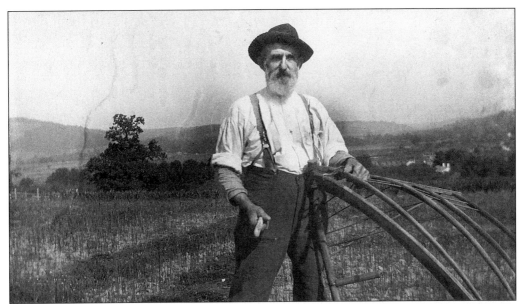

During the pioneer era, forest and land were considered expendable resources, and no thought was given as to what would happen when both were exhausted. Trees were used for building homesteads, barns, fences, shingles, and barrels. The need to clear the land and the need for ready cash also provided the self-limited business of selling wood ashes. One mile east of Oakdale, a hamlet developed called the Ashery, where it was possible to earn 12 cents a bushel for ashes. Among other uses, lye was leached from the potash. It is now known as the Stella Ireland area.

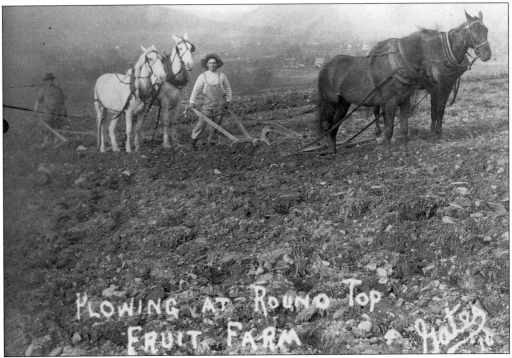

By 1920, there were 3,594 farms in the area, many of them on the cleared hillsides.

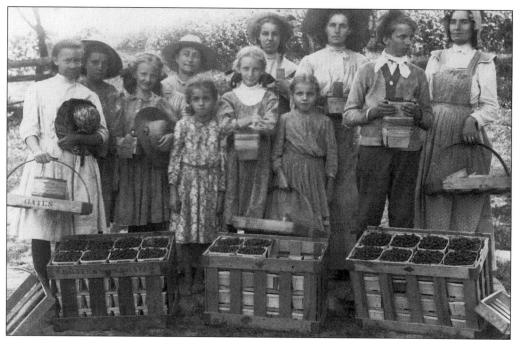

In 1910, in typical working dresses, some in bonnets and aprons, people earned approximately one quart of berries for every five they picked. Unless a minimal sum of cash was negotiated, then they might receive five cents for a day's work. Although this farm was located in Vestal, many similar enterprises were across the river in Union.

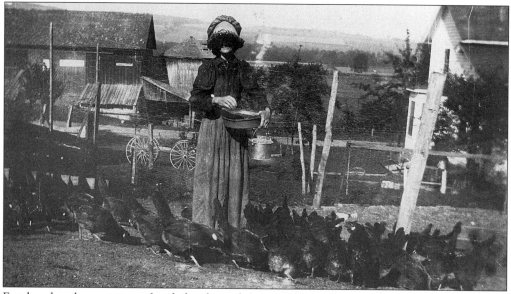

For decades, the economy of each family, and the nation, revolved around the farmyard. Nearly every home had a large garden and livestock. Chores were a way of life, and survival often depended on what could be produced and preserved at home. "Egg money" was sometimes the only cash income between harvests. This photo of an 1898 Town of Union woman and her chickens is particularly interesting because of the shadow of the photographer in the lower right corner.

With cash in short supply, instead of a dollar payment of tax, landowners were assigned to a length of time working on roads. The descriptions of boundaries were detailed, and today provide an excellent tool for locating lost landmarks.

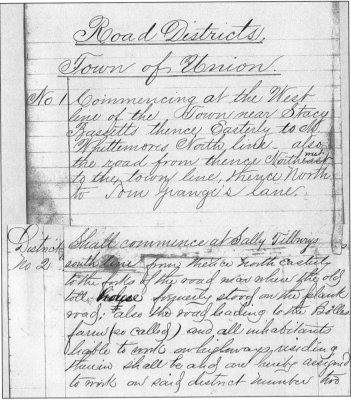

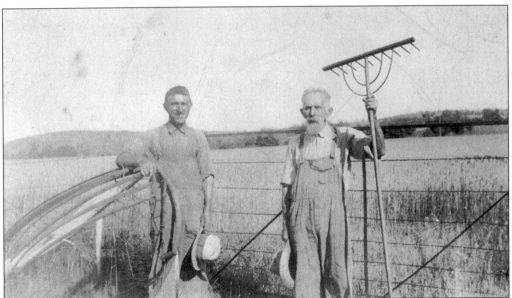

Local farmers with the tools of their trade, worked for themselves and for the community performing road repairs. A diary entry by a local farmer in June of 1889 recounts fulfilling his obligation to the road tax: "It commenced raining about 7'oclock but we went to work on the road at 8 and managed to put in a full day. That finished up the tax in that district as we were allowed 3/4 of a day for work did Friday. Going to bed early tonight."

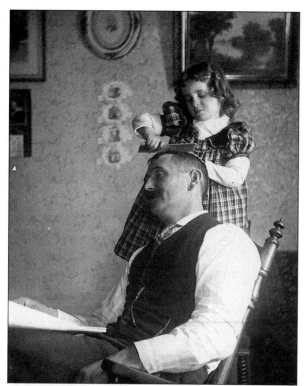

Entertainment and fun were simpler nearly a hundred years ago. In 1900, this small child combs her father, Dudley Mersereau's, hair, and later they share merriment and a bowl of popcorn. Dudley lost one eye while working as a fireman on the railroad. His hobby and passionate interest was in circus life, and he knew where all the circuses in the United States were performing at all times.

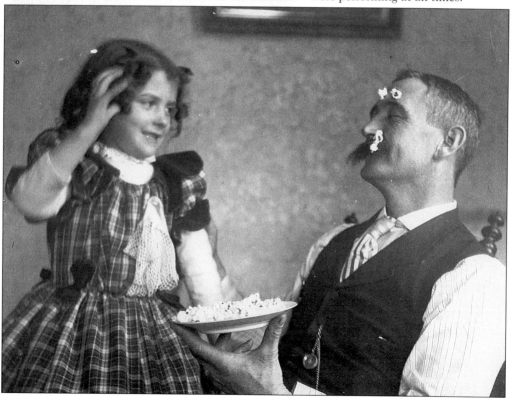

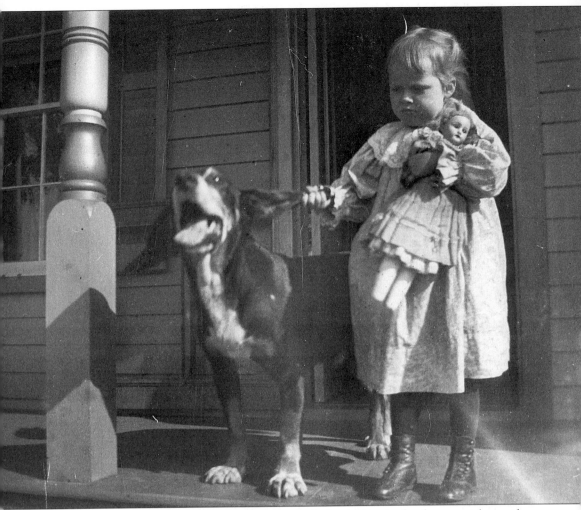

The legend accompanying this photograph tells of a little girl lost in the dense woods near her Town of Union home. Frantic parents and neighbors gathered to search, many bringing hunting dogs to track the child. Hope was dwindling after two days of diligent searching, when the baying of a hound was heard. More than a mile from her home, trapped in a forest ravine, the girl was found nestled against the barking dog. Although the animal belonged to a neighboring farmer, the dog refused ever to leave the child's side again. However, there is a true story which accompanies the legend. This photo appeared in a local newspaper in the 1980s along with other historic items. It was a great surprise to an octogenarian who recognized herself as the child with the dog. Admitting to being a difficult little girl, as the picture would indicate, she has no idea why she was grabbing the ear of her grandfather's dog. The lady went on to become a respected local teacher, and has now passed on, but before dying, with characteristic humor she indicated that perhaps a better title for the picture would be "Grumpy and Puppy."

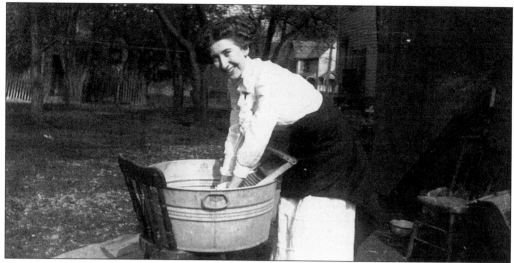

Happiness on washday? Not likely . . . this is obviously a posed photograph. The lady is not dressed for household chores, but for an outing, wearing lace at her throat, long sleeves, and shined high button shoes. The reality was a lot of hard work, boiling kettles of water and hours of scrubbing with rough soap. Washboards were used, metal fronts for the heavier clothing and a smaller glass-faced board for the delicate fabrics.

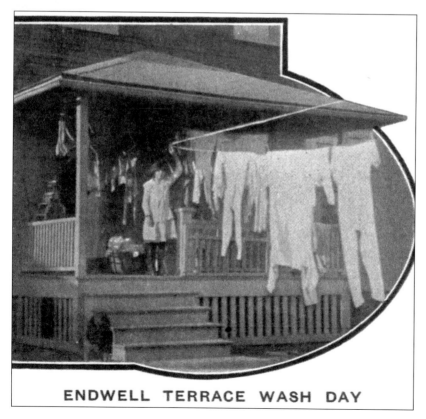

ENDWELL TERRACE WASH DAY

A wash day in 1920 was still no easy chore. Long underwear and clotheslines were a necessity. This photo was taken in Endwell, formerly Hooper, New York.

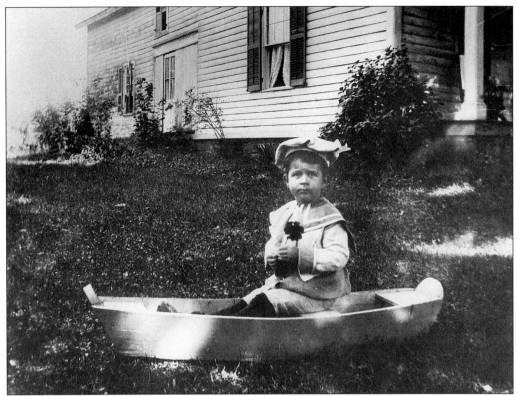

Sailor suits and little boys are a duo regardless of era. Why the young gentleman is in a boat in the front yard is probably just the whim of the photographer in 1900.

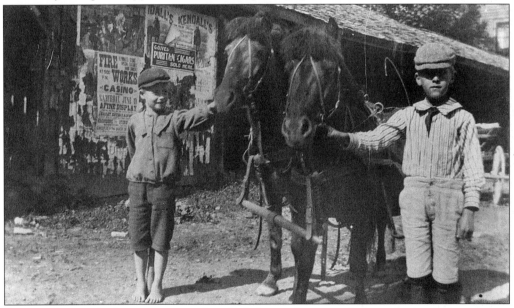

Summer dust settles between toes and on high button boots, each footprint leaving a memory. The boy on the right was out to earn a few cents providing rides in the family trap. Note the poster on the barn in the background advertising fireworks at Casino Park.

The corner of Badger and Main Street in Union was the setting for a snowball fight in 1906. A black smith shop and a firehouse are in the background.

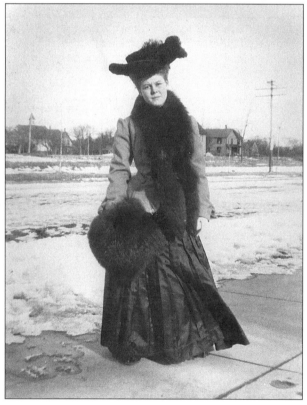

In 1900, the cold weather brought forth layers and layers of elegance, often topped with a fur neckpiece and muff. The muff has been a fashion item for hundreds of years, constructed of everything from velvet to cat fur. In an earlier century, it was acceptable for men as well as women and children to keep their hands warm in a muff.

Two
LIFE AND PROGRESS

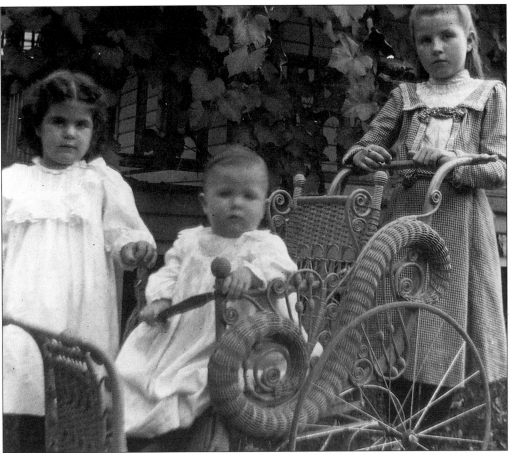

Wooden sidewalks were considered great progress in 1905. They lined the business section of the town, and were often filled with perambulators. It was the duty of the older sisters to entertain the baby and make sure the child was outside often to "take the air" in order to maintain health. Therefore, carriages were a common sight on the elevated walkways.

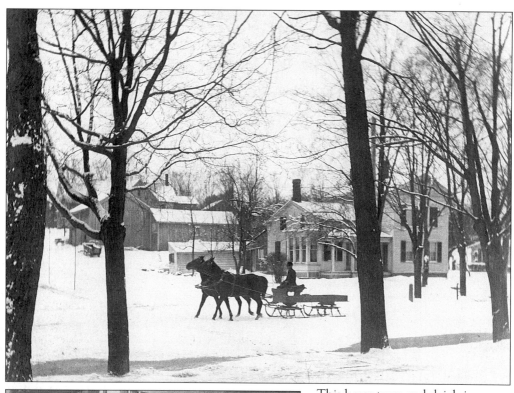

This horse team and sleigh is traveling on the snow-covered streets of Union, near Main street, c. 1910.

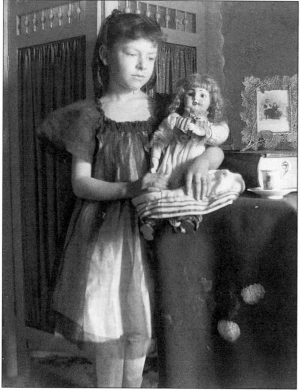

Note the delicate yet elaborate photo frame on the table in this 1899 image of a young girl with a very well cared for doll.

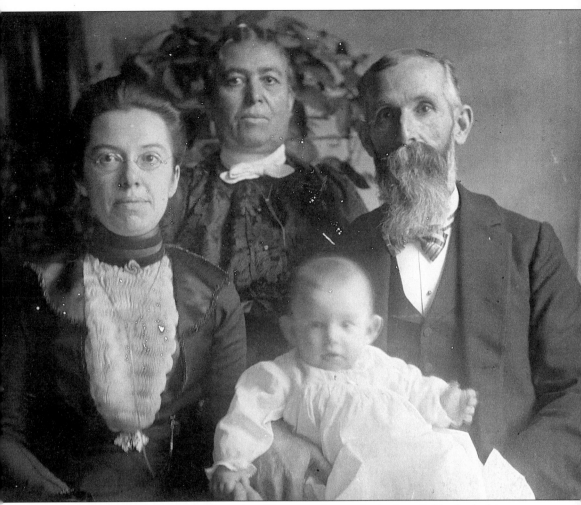

Having a photograph taken was a formal, stiff event, when only the best Sabbath clothes were worn, to impress posterity. The photographer would set up elaborate equipment, announce that everyone should look natural, but not to move or blink for 30 seconds, to three minutes, the time depending on the method of photography used. This typical Town of Union family is obviously deliriously happy in 1905.

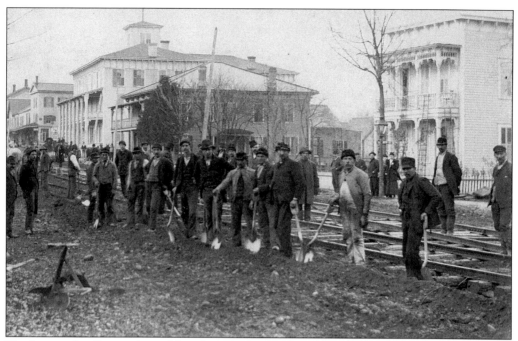

The laying of trolley tracks on Main Street was a great occasion. The Major House, an Inn and Tavern, is in the background of the photo above, and to the left of the trolley in the photo below. One if the most notable features in the house was a springboard dance floor, c. 1830–1840.

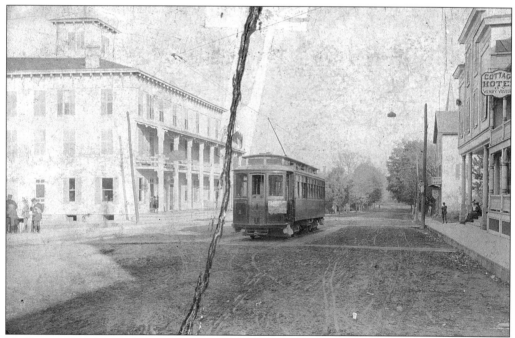

Trolley tracks, slime, slush, and smell made crossing the streets a daunting experience in the late 1800s. This is one good reason for the elevated sidewalks noticeable along the Main Street shops.

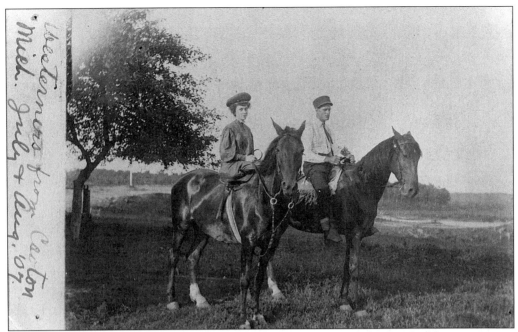

The lady in this photo was a well-known eccentric in 1900. Local lore tells us that in her youth she was left at the train by a vanishing love. Each spring thereafter, she would dress in long skirts and a huge hat, and run up and down the tracks for days at a time. As her behavior was non threatening, and predictable, town folk accepted the strangeness calmly, with only the occasional comment, "must be spring, Ruth's running the tracks again."

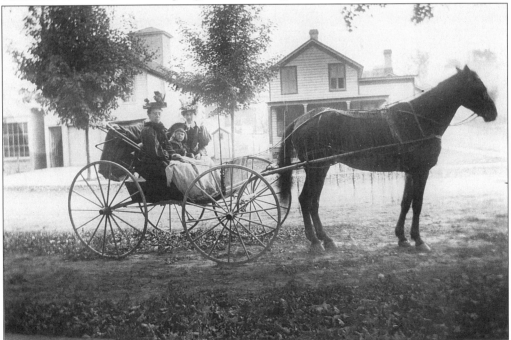

A buggy was also common on the roads, usually only seating two people, but convenient for visiting and displaying the latest in millinery fashion.

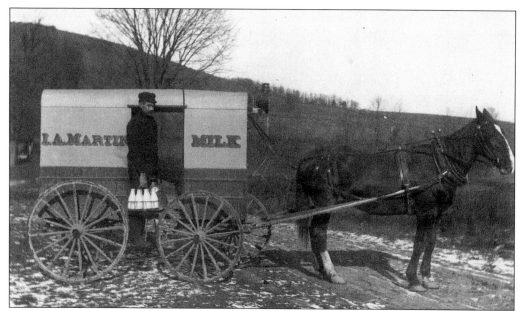

In many towns the butcher, the baker, and the milkman made deliveries right to the customers front door, even as late as the 1940s. Those were the days when morning was a fresh dollop of thick cream in the coffee or on berries. The tinkling of empty milk bottles being exchanged for full ones, and placed in a tin cooling box on the steps, was often the herald of dawn.

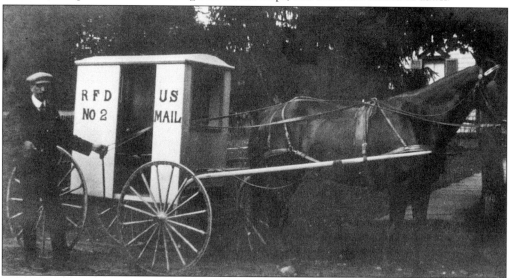

When horsepower had four legs, in 1910, Mr. Hoppler was the local mail delivery service. He and his faithful steed, Stamp, made the rounds between Lestershire and Hooper, (now Johnson City, and Endwell,) dispensing mail, local gossip, occasionally quince jam, and often pithy advice. One of his favorite tips was on the proper mixture of worms with the juice of a local weed "to catch as many fish as to feed a family of 16 for two days." In 1850, an official Hooper Post Office was established. In 1921, a new name had to be chosen for the hamlet, as there were too many towns in the NYS Post Office system with the name of Hooper. Endwell was picked after much discussion. The true source of the word may never be known, but at the time, the *Endwell* shoe was being manufactured by the Endicott Johnson Corporation.

Prohibition began with the Volstead Act of 1919, continued until 1933 when the twenty-first Amendment repealing Prohibition was ratified. During the temperance movement, spirits were banned, and law enforcement officers had an endless task trying to stem the flow of bootleg liquor. This Town catch of illegal apparatus probably ended up in the Susquehanna River, as the usual practice was to dump the confiscated stills and slot machines into the water, sentencing them to rust. Local police detectives Seaver, Coleman, and Wilson are posed with the copper culprits.

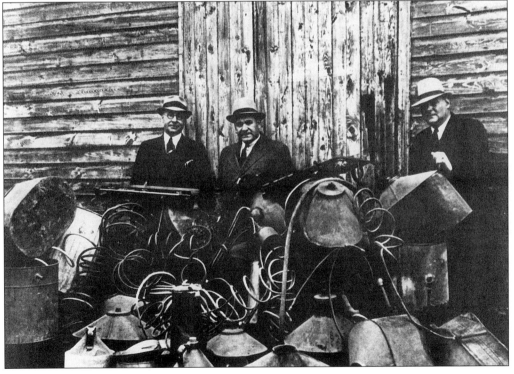

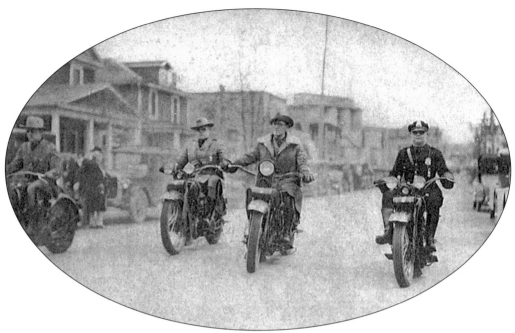

A welcome home parade for George F. Johnson was a tradition. He and his family spent part of the year at a Florida residence, and on his return the community would celebrate. A parade gave the local police force an opportunity to exhibit the efficiency of law enforcement, on wheels, in the 1920s.

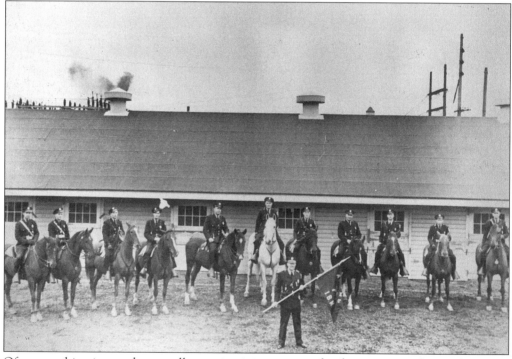

Often marching in parades as well as maintaining security for the growing industry, the IBM's Security force is shown here on horseback in 1946.

Three
LABOR, LEISURE, AND LANDMARKS

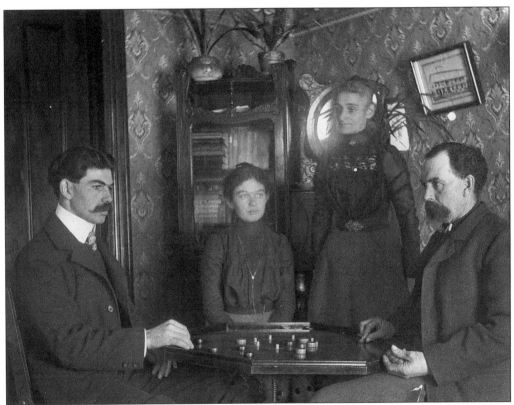

In 1910, this was an exciting moment of leisure time action. A rousing good time was being enjoyed around the family game board. The game of Crokenol was the rage in Union, as exemplified by this lively party.

History can clearly be traced in the progress of building Washington Avenue in Endicott—from 1895 when it was still muddy ruts to 1900 when the original streets of the area were being laid out.

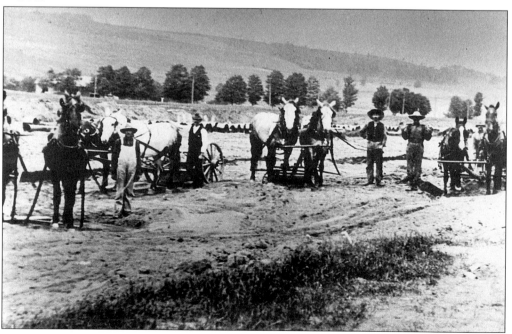

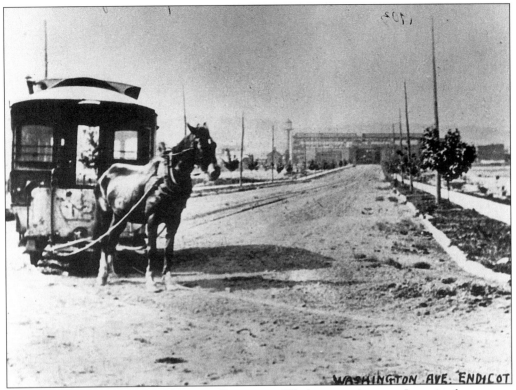

The year 1903 brought horse-drawn trolley cars to Washington Avenue. Later in the century came the paved streets and parking spaces of the automobile era. In both these photographs, prosperity is seen at the end of the street as the Endicott Johnson Factory.

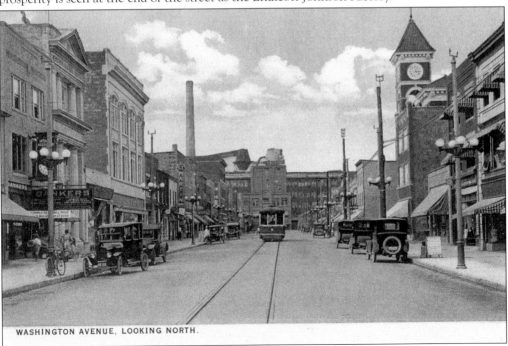

WASHINGTON AVENUE, LOOKING NORTH.

H. L. WHITNEY,
—AGENT FOR—

"Surely the road to fame is via the bicycle, in this enlightened age."

:-: Warwick Perfection Safety, :-:

Also the Celebrated BRONCO,
without chain or other friction, something entirely new for 1890. Best in the world. We warrant our Machines to have no Cast Metal in their construction.
Also, constantly on hand, School Supplies, Fishing Tackle, Base Balls and Bats, Drugs, Oils, Paints, &c. No use going to Binghamton when you can buy at home.
Bargains in houses and lots,—low.

The Lestershire—Union bicycle path was built during the 1890s and paved with cinders, so cyclists could avoid the congestion of main roads. Riders were required to wear a badge, indicating that they had purchased the right to use the path for a year, at the cost of one dollar. Folklore proclaims that the cinders were obtained from shoe factories, and were full of tacks, prompting complaints from owners of punctured tires. Supposedly, the situation was saved by the use of a huge magnet being dragged along the path to collect the sharp hazards.

The wheels of time roll through the town of Union. Weary of travel by horse, mankind seized upon the opportunity to propel themselves on wheels. From the wooden "boneshaker" bicycle model to a 1911 motorized version, bicycling became a necessity, recreation, and a sport. The weekly papers gave results of bicycle races, and competitors became heroes. By the late 1800s, even the most conservative element of society agreed that women were "competent to wheel without impinging on maidenly virtue . . . or the safety of others."

IBM provided economical customer service in 1957, as this gentleman on his pedal-powered vehicle exemplifies.

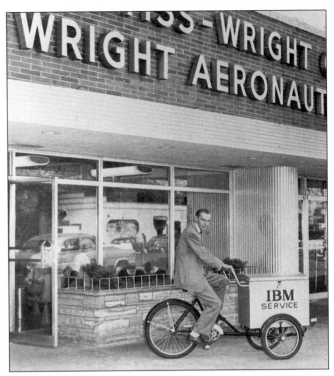

Humor, poetry, and silly stories were inspired by the cycles craze. In 1897, the *Binghamton Chronicle* included these tidbits on their regular centerfold about cyclists:
A Country Run / Sand above the sprocket-wheel, / Mud above the chain, / Wind at thirty miles an hour Ruts and rocks and rain. / Dogs before the farmer's house / Chew your legs for fun, / Nails and glass and mud and sand - / That's a country run.

"Churches are paying more and more attention to wheelmen, and the general opinion seems to be that the man or woman who rides a bicycle is not really a bad personage, but quite capable of appreciating good and courteous treatment."

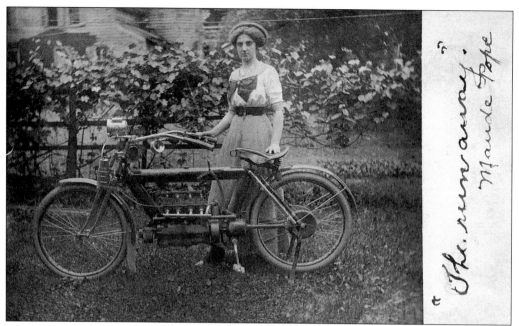

Maude Pope of Lestershire, New York, at the age of 19, rode through the streets on her motorized bike in 1911.

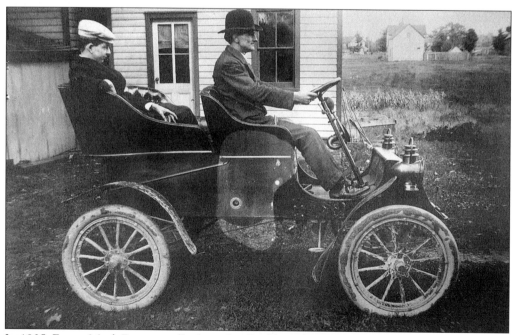

In 1905, Ernest Mack Rose proudly drove his Ford horseless carriage on the streets of Union.

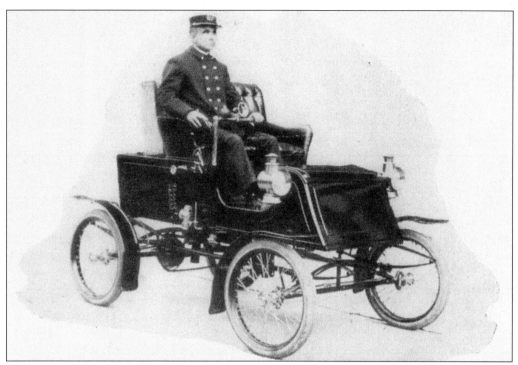

Lestershire's first auto arrived in 1903, and the first car owner was W.G. Faatz, the chief engineer of the Fire Department.

In the 1930s, a traffic light was cause for celebration. Once upon a time traffic lights were so unique and new that the whole town showed up to see one activated. When the first one was installed in Johnson City, Mayor Lampman and several trustees doffed their hats and joined the crowd in cheering the beacon of progress as it flashed red and green.

In a booklet printed in 1925, this photograph of Hooper Curve is referred to as the "good old days that were not so good." "Gone forever are the single track trolley, and dirt roads and wagons." The photo was taken in 1897.

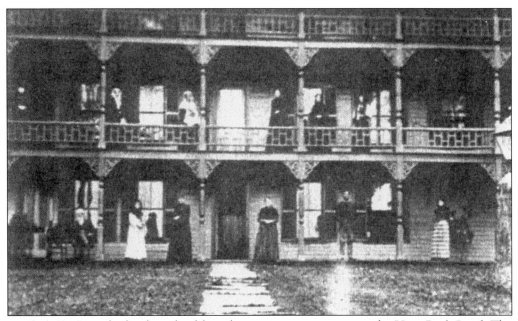

In 1885, Dr. Doan built a large health and water cure sanitarium on the Hogs Back Road. The most interesting fact about the institution is the lack of information concerning its existence. The facility disappeared, the road name was changed to Glendale Drive, and decades later, the IBM Laboratory was built on the site.

Energy drawn from the wind on North Street in Endicott was once the site of this power source for a farm well. Windmills were common in 1908. Gault Chevrolet, a car dealership, is now located on what was once busy farmland.

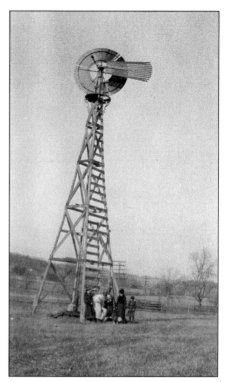

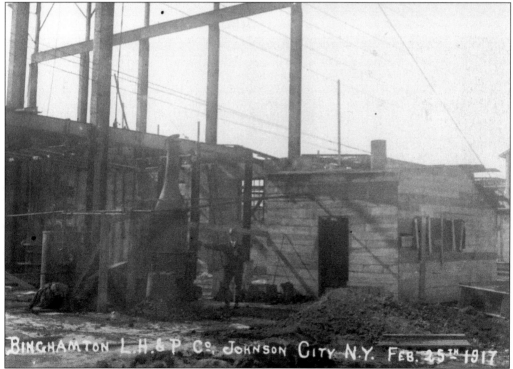

The year 1917 brought innovation to the power scene. The Binghamton Light Heat and Power Company was located in Johnson City. Mr. Leon Bates is at work near one of the boilers.

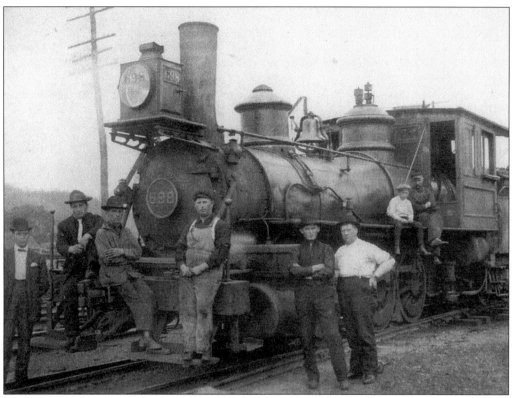
This was one of the earliest railroad steam engines to come through Union.

A peaceful country road leads to the bridge connecting Vestal and Union, about 1910. The first free bridge was not built until 1870. Before that time a toll was charged for each vehicle, animal, and human to cross the river in safety.

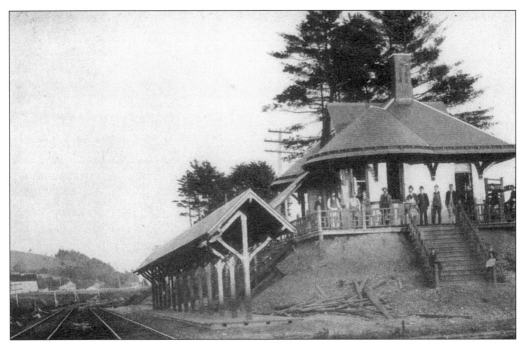

Local industries attracted progress in the form of the iron horse. In 1890, the Erie Railroad station was new and prosperous, in Lestershire, New York.

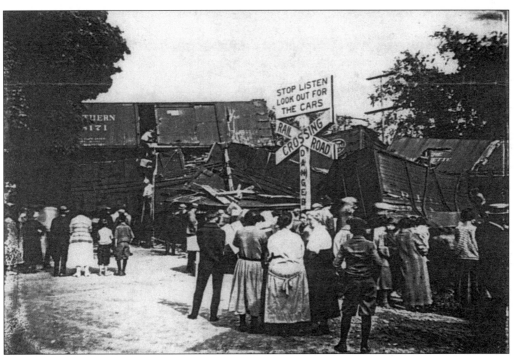

Entertainment has always been a matter of interpretation, and even a disaster qualified as a moment to join with ones neighbors and grab the news firsthand. This railroad crash at the site of the Avenue B intersection was said to have kept the community buzzing for weeks.

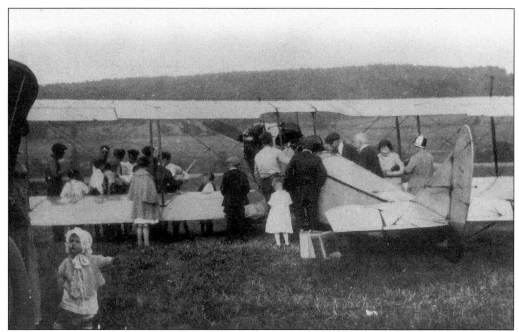

In the 1920s, dreams turn into reality, as biplanes land in a field in West Endicott. The child in the foreground is Marjorie Burly.

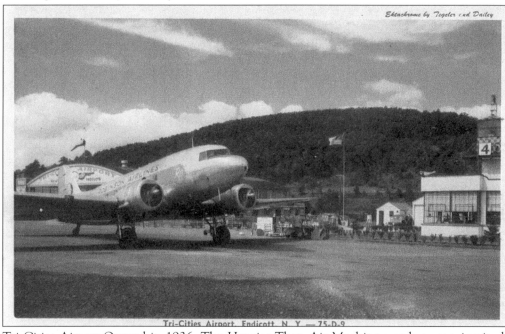

Tri-Cities Airport Opened in 1936. The Heavier Than Air Machine was busy proving itself during war and peace, at a location most locals anticipated becoming a hub of international air traffic. Although still in use, the Tri-Cities Airport is currently visited only by small local aircraft. The airport is beautifully maintained and updated, but with an atmosphere that encourages one to imagine a bi-plane swooping through the clouds, guided to a landing only by pilot daring and a wind sock.

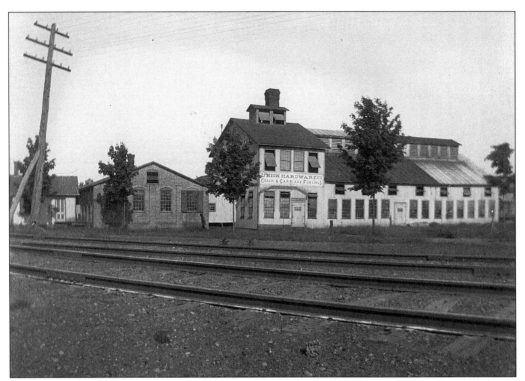

The Union Hardware Company was established in 1883, making it the oldest business in the Town of Union. It manufactured coach and carriage forgings, and went on to become the Union Forging Works, located on North Street in Endicott. It was in operation until the 1990s, and is currently part of an ecology recovery program.

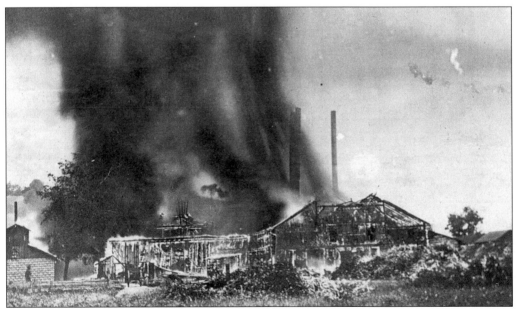

This photograph, widely sold as a souvenir postcard, was taken during the great fire of 1900, when most of the Union Forging works burned to the ground.

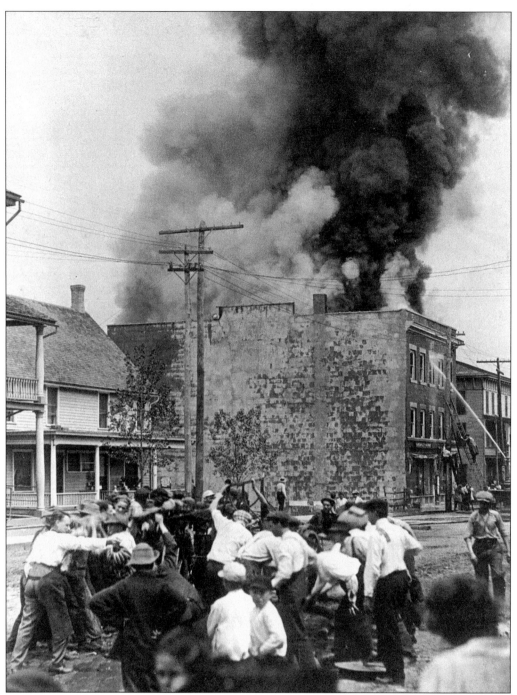

This letter was sent from a mother living in Union to her son in California in 1901:
"Dear Archie, Papa bought these pictures for you, of the fire. This one was taken immediately after the explosion that caused the cornice to fall that killed Rodman and injured others. You can see what a black smoke there is. Papa said it was the worst smoke he ever worked in. They think Ed Giles will recover now. But he will always be a cripple. They found his heel of his right foot under the brick when they cleaned it up."

The letter continues, "Do you see Hal Z. in this picture I put a cross on his back? Also put a cross on Lewis Whitney's back and just behind the girl that stands by him is his mother in the plain dress. Down under the walk was where Rodman was killed and the others injured. You can see very plain where the cornice is gone from the building. That is Papa up on the roof of Uncle Harlans store on the short ladder by the chimney, holding the hose. The sidewalk was piled full of household goods and other goods on both sides of the street. Uncle Harlans store is where the baywinds is and where the awning is down Shirly (that bought-out Warner) has that store. Think the pictures are quite plain, and guess you can get quite a good idea of the fire."

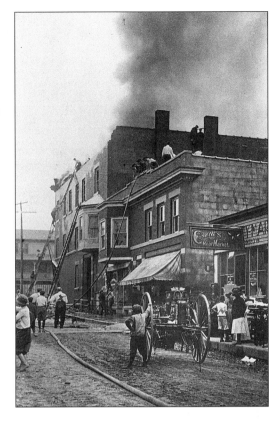

Frank Tillbury, a member of one of the most well known families in Union, served as a volunteer fireman in 1919. He is the Papa referred to in the letter, and one of the men fighting the fire in this series of photos.

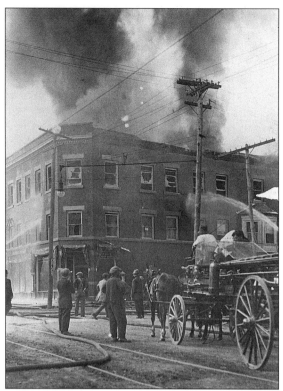

The letter continues, "This is another view of the fire taken on the corner over by the corner of Exchange Street. Endicott Hook and Ladder shows in this one. Do not know as they would have gotten the fire out if they had not come. Anyway they did good work. All the roof and first top story are entirely burned out and only the walls stand. You can see where the cornice is gone. A boy of six years son of one of the teachers, Professor Bean that lived over Uncles Store, set a fire and the air shaft acted as a chimney."

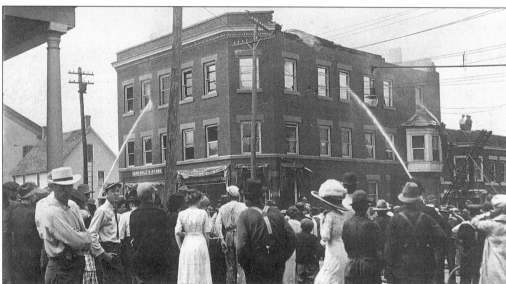

The letter continues, "In this view you see the fire is about out. Do you see Walt Surdam looking this way, I put a cross on his shirt front. You see they are letting down the ladders (some of them). It is a tough looking building now. They think that they can use the wall without taking them down. Brown intends to rebuild as soon as he can.. Smith the druggist on the corner is going over to Loisi's store where Fred Brown used to be and Unell is going over on the store where Criss Mersereau used to be. The insurance adjusters have not come yet. A small boy and matches are a poor combination. " The letter is signed "Mamma."

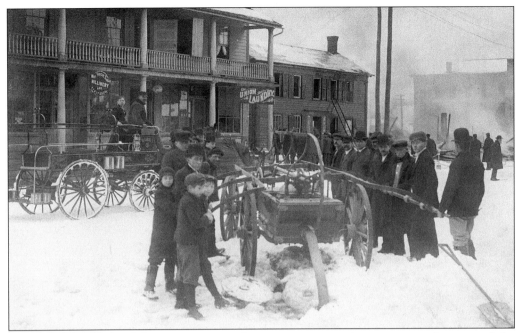

Bells on the wheels of fire wagons were the emergency warning system at the turn of the century. A bucket of water for dousing fire was kept near the front door of every homestead, and was a considered community responsibility. Pumping the water by hand operated piston pumps was the most modern way to fight fires in 1899, when another drug store went up in flames.

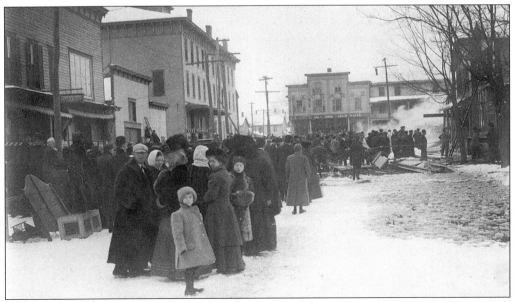

The store that is burning down in this photo from February, 10, 1910, made from a glass negative was on the corner of Nanticoke and Main Street, before the Corner Drug Store was built. The business belonged to LaVina and Job Warner.

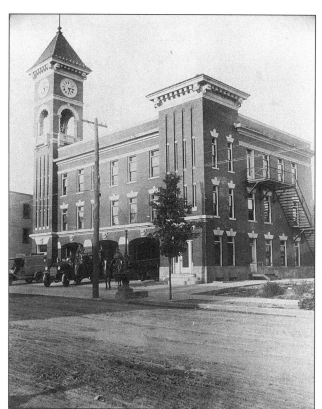

The Central Fire Station was erected in 1912 on Washington Avenue in Endicott, New York. An addition was put on in 1919, and for many years, the station was the signature landmark for downtown Endicott. The building was torn down and a bank is now on the site.

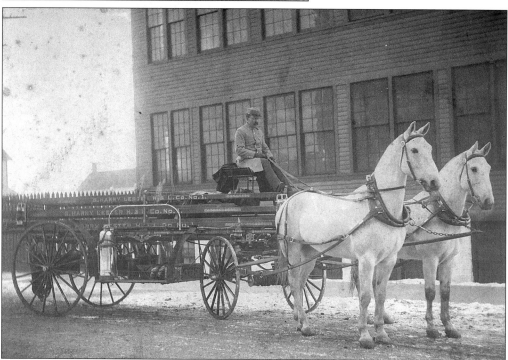

The G. Harry Lester Hook and Ladder Truck is shown here on the streets of Lestershire in 1898.

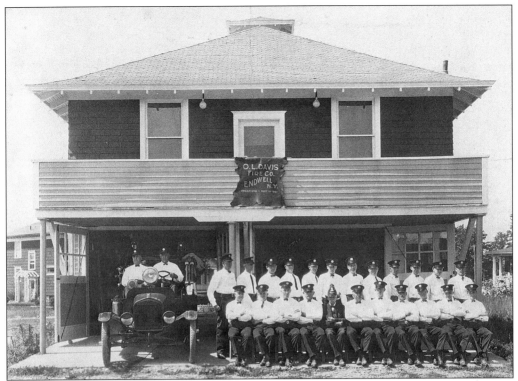

In 1921, Orlando L. Davis knew that fire protection was needed in the Endwell area of Union. When he lost a loved one in a fire, the knowledge turned into action. He worked tirelessly to organize a fire company, and donated land on which to build the station house. The company he created is shown above. The first motorized fire truck in the station was a Model T Ford, purchased in 1929.

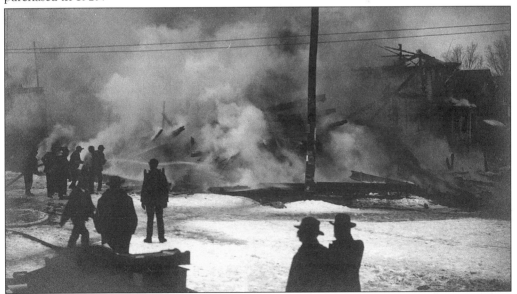

The devastation of fire through the artistry of the camera is captured in this silhouette of a fire in 1909.

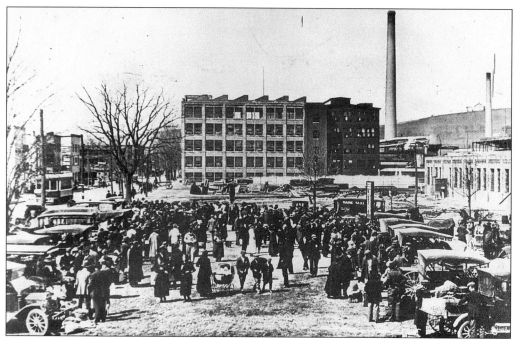

A public market existed as early as 1915 in Endicott, at the corner of North Street and McKinley Avenue. In 1920, the market was renovated, and the following rhyme appeared in the *EJ Workers Review*:
"Where are you going to, my pretty maid?"
"To the NEW Public Market, Sir," she said
"What's the idea?" he next inquired
"Why, old Mr. Hi Cost is going to get fired."
"And he did get fired right and proper. The good housewives of Endicott turned out, armed with baskets and receptacles in large numbers, for the grand opening on April 30."

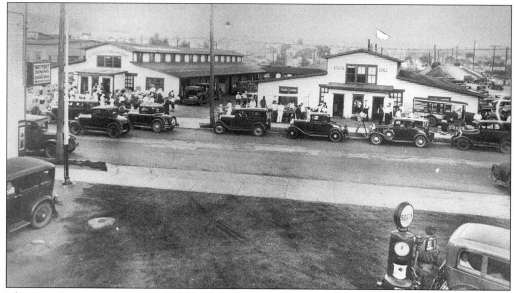

This is a view of the Endicott Public Market in 1933.

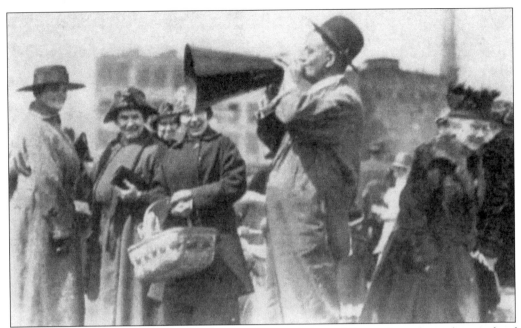

Mr. Patterson, The Market Master, was in charge of the public market where thousands of people bought their groceries, meat, and fresh vegetables. All food was sold practically at cost. Ten-pound pails of mackerel were selling at $1.75, and old-fashioned corn meal was all of four and one-half cents a pound.

Posted on the market board were the prices of the day. Note the last item on the list, woodchuck, is not often found these days for 30 cents a pound, or for any price.

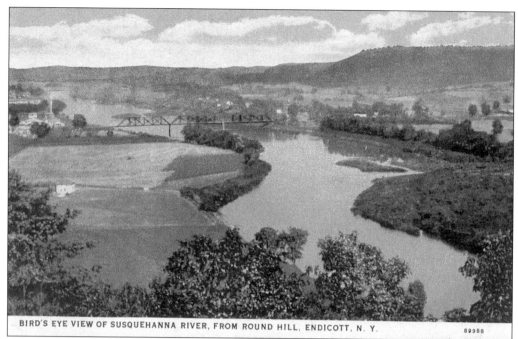

BIRD'S EYE VIEW OF SUSQUEHANNA RIVER, FROM ROUND HILL, ENDICOTT, N. Y. 89988

This view is from Round Hill in the early 1900s, over looking the valley. Both Native Americans and settlers took full advantage of the bountiful food source offered by the river. Fish, turtles, eels, beavers, and otters all made their way to the table. Shad fishing was considered best at dusk, and hundreds of large nets were filled with the delicacy nightly. Eventually, this fish all but disappeared from the waters, as dams, refuse from the mills and factories, and over fishing took its toll on nature.

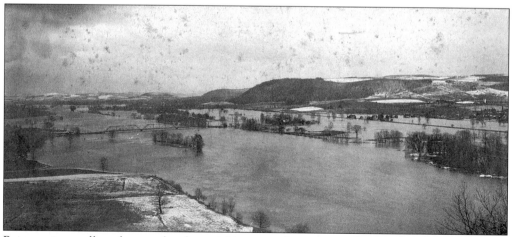

Being a river valley, the area has been subject to a few massive floods. This photo was taken during the flood in the early 1900s.

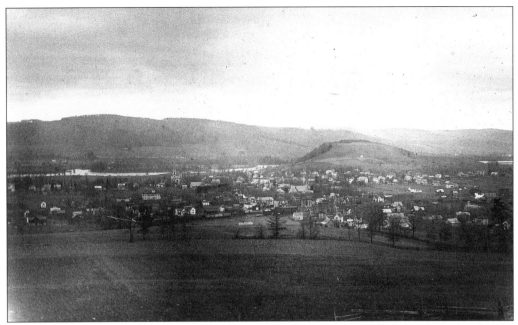

This Round Hill (Round Top) photo probably taken from Dunlop Hill about 1900. An obvious landmark in the Town of Union is Round Hill, referred to as Round Top by local people. It rises from the banks of the Susquehanna River to a height offering magnificent vistas of the valley. Remnants of Native American habitation have been found in profusion, spread across the broad summit. Stone tools, points, sinkers, and drills all give credence to a legend that this high point was once used for Indian signal fires and temporary camps. Homes are now built along the hillside, and the top is a passive recreation area. The panoramic view both day and night has attracted lovers of nature and romance for generations. The bottom photo captures a view from Round Hill in the 1930s, overlooking the "Valley of Opportunity."

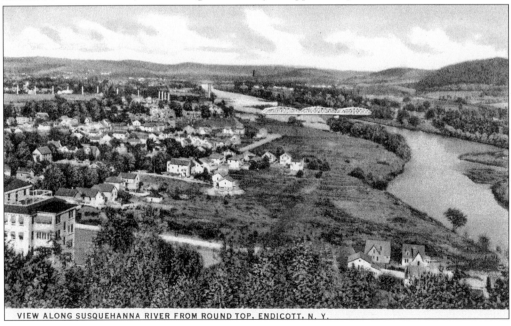

VIEW ALONG SUSQUEHANNA RIVER FROM ROUND TOP, ENDICOTT, N. Y.

Report of A W Whittemore
Overseer of the Poor Town of Union

Union, N.Y. Year Ending Dec 31st 1908

NAMES.	Native Country	Cause of Pauperism.	Males	Females	Total	Transportation Expenses.	Overseer's Services.	Amount of Temp'ry Relief
		1907 Dec 31 Balance on hand				125 57		
		1908 Mch 24 Rec'd from F Whitteman Supr				50 00		
		Nov 6 " " " "				50 00		
		" 10 " " " "				50 00		
						275 57		
Burrill Thos	Scott	Old Age	1				2 00	
Bean Mrs Louisa	US	Old Age		1				50
Conlon James	"	Insanity	1				1 00	10 00
French Jerry	"	Opium eater	1					3 50
McNamara Thos	Ireland	Intemperance	1				2 00	6 00
Nelson George	U.S.	Sick	1				2 00	78 00
Pierce Otto	"	"	1				2 00	28 98
Rackett Herman	"	"	1				2 00	7 69
Sloboda Frank	Slav	"	1				2 00	
Shed Frank	U.S.	Accident	1				2 00	12 40
Taylor Archie	"	Sick	1				2 00	24 00
Wood Clayton	"	Intemperance	1				7 00	74 76
Perkins James	"	Accident	1				2 00	
Wilson Bertha	"	Insane		1			1 00	5 00
		Balance on hand						25 24
								275 57

We the Undersigned members of the town board of auditors of town of Union Broome Co., NY do hereby certify that we have examined the accounts of A W Whittemore Overseer of the Poor of said town of Union and find said accounts true and correct and that there is due from said A W Whittemore Overseer of the Poor a Balance of 25 24

F. E. Whittemore Supr.
G. F. Eckert Justice of the Peace
W. L. Edson " " "
W. Kay Humphrey " " "
D. W. Warner Town Clerk

The year was 1908, and the Town of Union provided the Overseer of the Poor with $257.57 with which to care for the indigent and helpless. It is interesting to note the causes of "pauperism." Opium eater, insanity, and intemperance were included along with the more mundane affliction of advanced age.

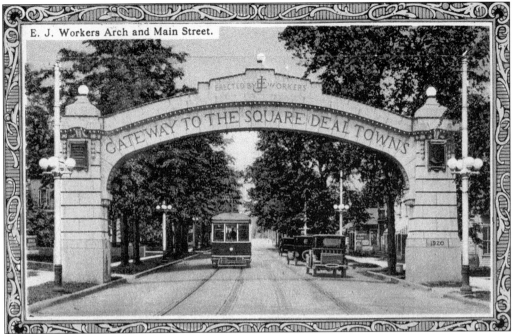

E. J. Workers Arch and Main Street.

In 1920, two stone arches were constructed over Main Street. One was located at the boundary between Binghamton and Johnson City, and the other at the western line of Endicott. Both were paid for by Endicott Johnson workers to honor company management, opportunity, and "Square Deal" policies. Originally illuminated with lights, they were beacons of the local attitude. Both arches have been renovated, but still stand as proud landmarks.

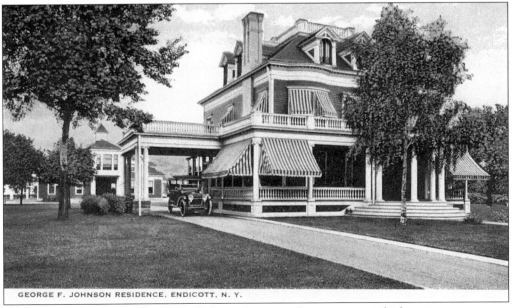

GEORGE F. JOHNSON RESIDENCE, ENDICOTT, N. Y.

The home of George F. Johnson in Endicott became a lasting memorial when it was put to use as a library for the community in 1950. However, elegance, class, and excellent craftsmanship could not withstand the wrecking ball, and the building was demolished to make way for a modern structure in 1967.

New Carriage Shop

IN UNION.
NEW FIRM.

THE Subscribers having entered into co-partnership in manufacturing Carriages, Sleighs and Wagons of all descriptions, one door east of the Foundry, are prepared to do all kinds of work entrusted to them with neetness and dispatch.

☞ Carriages, Wagons or Sleighs got up to order at the shortest notice.

As we have had much experience in this department of our business, those wishing a job of the kind executed with a view to profit and durability, will do well to call on us. Particular attention will also be given to the making and repairing of edge tools. Repairing and custom work of all kinds except shoeing, promptly attended to. Please give us a call and satisfy yourselves.

⁎⁎⁎ Terms cash or ready pay.

JOHN D. HAGADORN,
JOB HAGADORN.

Union, Sept. 30, 1856.

The growing population of the valley made locating a business in the area very attractive.
As the times changed, the industries adapted, as did the talents of the people, from horse and carriages, to machines and engines.

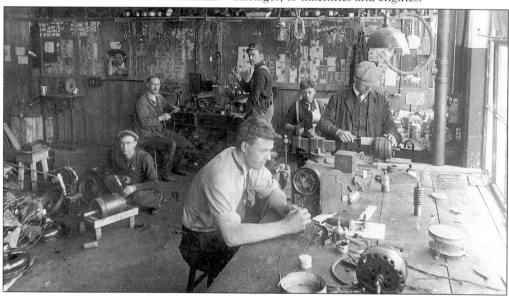

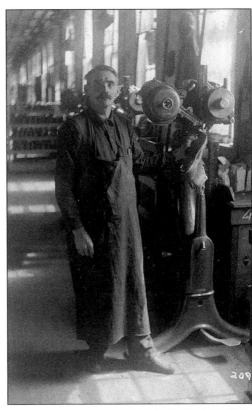

Byron Patterson enjoyed the security of steady employment at the Endicott Johnson Shoe Factory, about 1912.

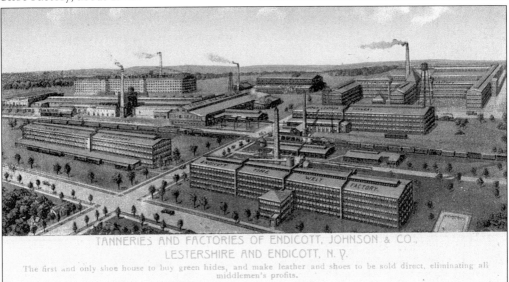

Industrial prosperity was brought to the Town of Union in 1899 by boots and shoes, beginning with the Lester Boot and Shoe Company, the parent organization of EJ. The business grew and attracted many hundreds of workers from all parts of the United States and Europe. This is a composite of the factories at the height of their production. "They were the first and only shoe house to buy green hides, and make leather and shoes to be sold direct, eliminating all middlemen's profits."

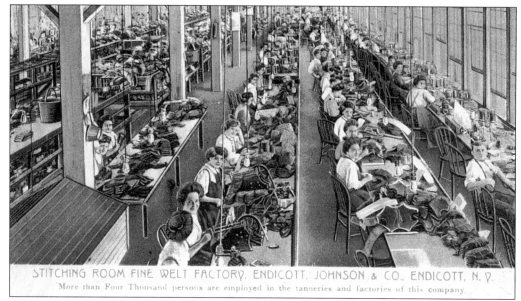

STITCHING ROOM FINE WELT FACTORY. ENDICOTT, JOHNSON & CO., ENDICOTT, N. Y.
More than Four Thousand persons are employed in the tanneries and factories of this company.

A huge stitching room in the Endicott Johnson factory produced a calliope of mass production sounds. Days began with the blare of factory whistles, signaling the start of work. As each factory whistle had its own distinctive pitch, area residents learned to recognize and take comfort in the regularity of the shrill noises; sounds that have now faded into the silence of the past. More than four thousand people spent their working hours constructing shoes at the time of this photo in the 1920s.

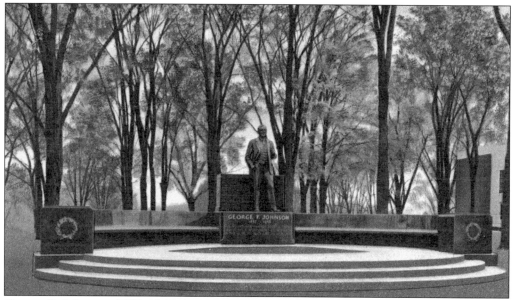

George F. Johnson, 1887–1947, began as superintendent for the owner, Mr. Endicott, and eventually became his partner. Under the guidance of G.F. Johnson, an era of unprecedented growth and giving was established. Schools, churches, homes, and parks were built by EJ to benefit the population. Many statues were erected to GFJ, and sites named for a great community philanthropist. His abiding philosophy was "the greatest good for the greatest number."

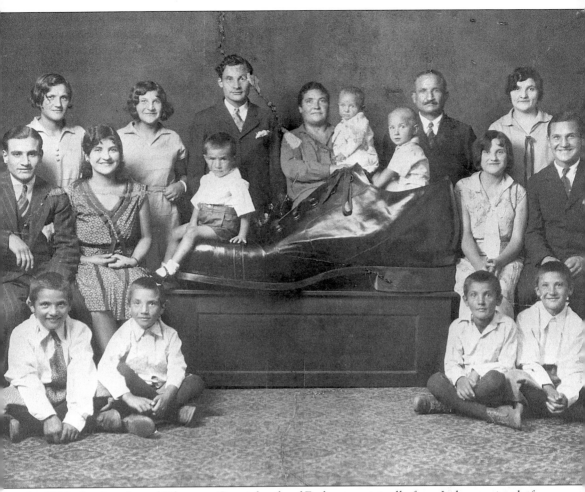

In 1930, the Angelo and Filomena Grassi family of Endicott, originally from Italy, consisted of the parents and fifteen children. They were considered the largest "Endicott Johnson Family" in Broome County. The father and all the adult children worked in EJ factories. George F. Johnson thought this was such a unique fact he wanted a photo of the whole group. EJ crafted a gigantic shoe, the idea of course originating with the nursery rhyme about the "Old Woman Who Lived In A shoe." A photograph was taken with all seventeen surrounding the shoe. Photo and shoe were displayed in the Main street EJ retail store, and then sent on a promotional tour around the country. The Grassi family could not afford "picture taking clothes," so George F. Johnson graciously offered to outfit them all, including new EJ shoes.

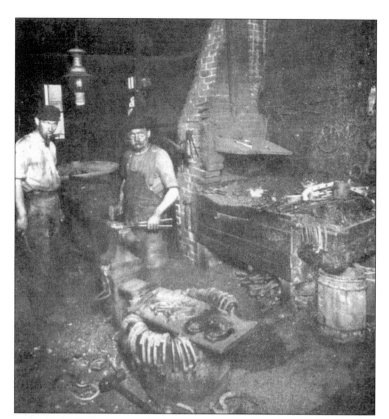

The village blacksmith c. 1860 was one of the most important men in the community. He kept the horses well shod, the carriages in rolling order, and could fabricate almost any item requested, from iron.

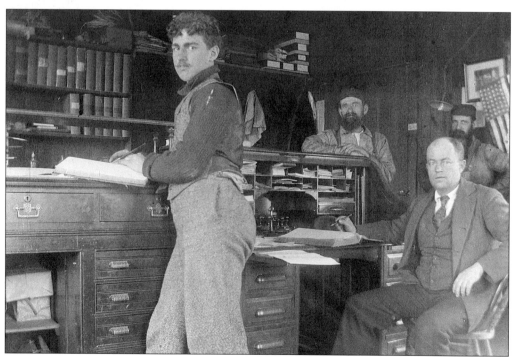

This was the front office of the Union Hardware and Forging Company in the early 1900s.

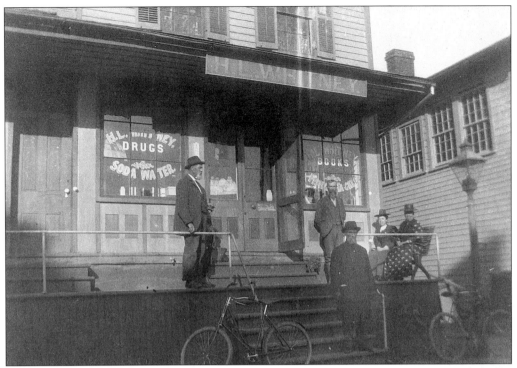

H.L. Whitney operated the emporiums in this 1900-style shopping center on Nanticoke Avenue near the side of the Corner Drug Store. The site is now an empty lot.

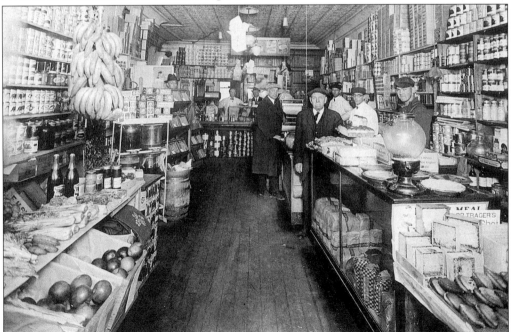

String balls hanging from a tin ceiling, bananas ready to pluck from a huge dangling bunch, scrubbed, creaky wood floors, the smell of fresh coffee beans and a pickle barrel, and both customers and clerks wearing "port pie" hats are the sights in this small-town general store.

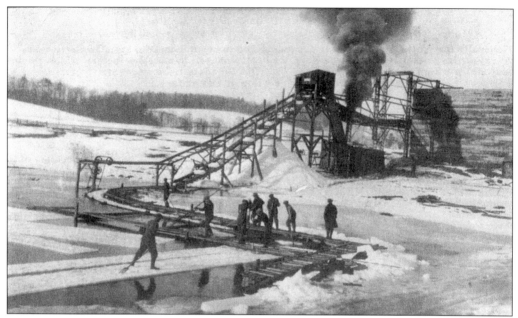

In an area now known as West Corners a very profitable ice business was conducted on Bosket Pond. In 1922, Oscar Bosket and Fletcher P. Neff purchased the pond and ice equipment, and kept their product in a large barn on the shore. The harvested ice was stored in sawdust until the summer heat created a market.

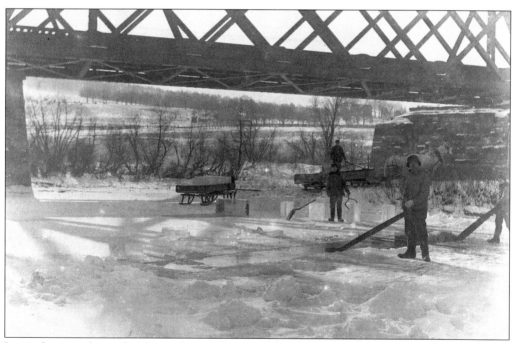

Ice is harvested on the Susquehanna River under the Union/Vestal Bridge in 1898. Ice harvesting on the river and from local ponds may seem to be an inexpensive and romantic way to provide cooling. The reality was that waterways were used for dumping refuse of all kinds. Many illnesses and deaths can be attributed to ingestion of less than pure ice.

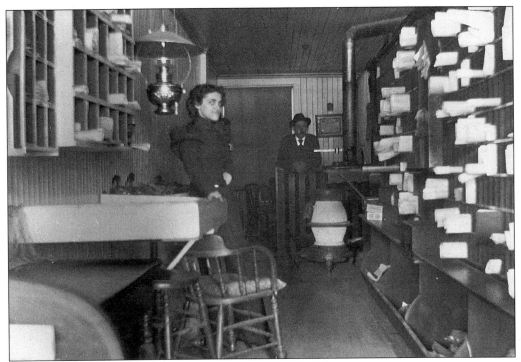
The Union Post Office as it appeared in 1905 is shown in this image.

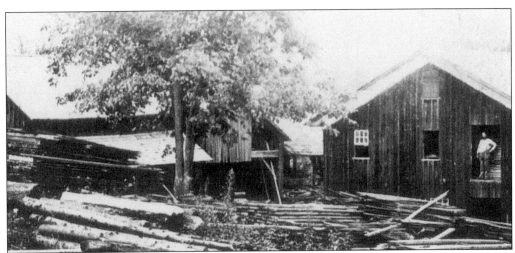
At one time, Union Center claimed many thriving businesses, including a cheese factory that operated from 1878 to 1880. This photo is of the Union Center Saw Mill built by Richard Bradley and Dowd Barazilla Howard. The saw mill and rake shop operated from 1859 to 1910.

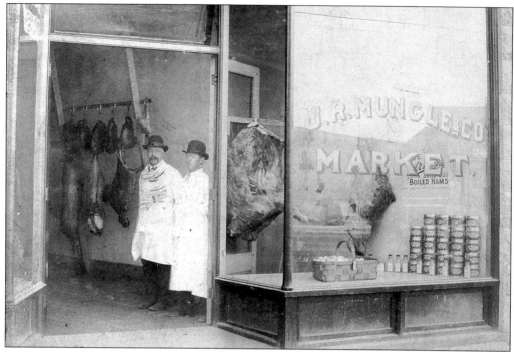

In the good old days of markets in 1900, shoppers were up front and personal with freshly killed flesh. The lack of refrigeration almost guaranteed a supply of flies and a bit of putrefaction. Many are the references in local housewives' cookbooks on ways to retard the spoilage and restore meat to an edible state. However sad some of the chickens looked, the butchers were quite dapper in their homburg hats and aprons.

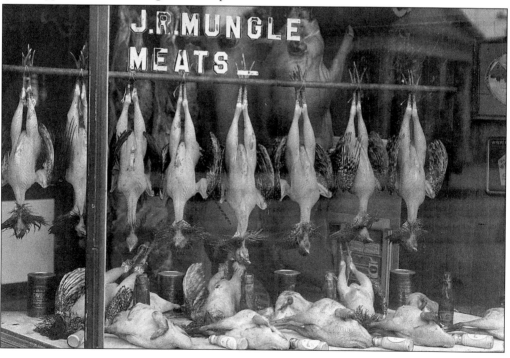

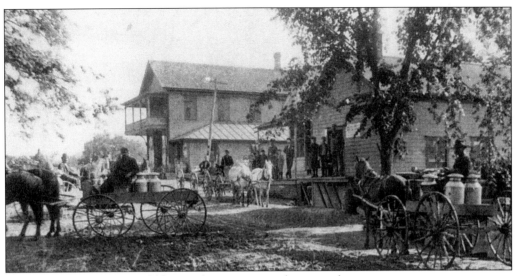

Union Center in 1906 could boast of its own general store and a creamery.

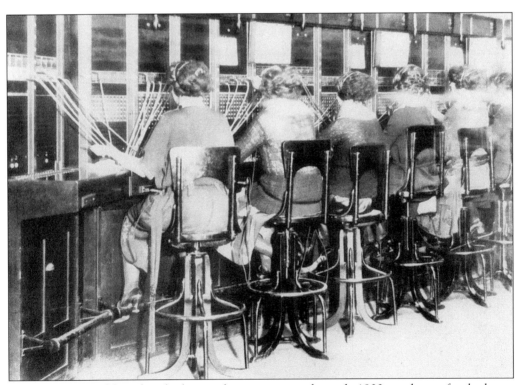

A telephone switchboard in the home of an operator in the early 1900s made way for the larger and more professional communications equipment of the 1930s.

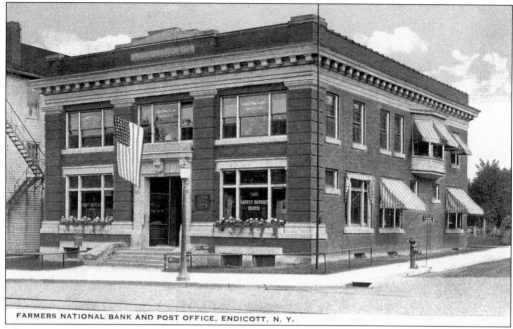

FARMERS NATIONAL BANK AND POST OFFICE, ENDICOTT, N. Y.

The Farmers National Bank of Union, New York was organized in 1908 with a capital of $25,000. The stately brick building was erected in 1910. For many years, it served as a landmark for the stability and elegance of another era. In 1996, the edifice was the site of a preservation controversy, resulting in the demolition of a grand building. In its place was erected a modern monument to the art of tacky, made of plastic and cinder block.

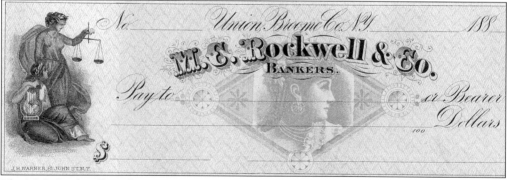

The M.C. Rockwell Bank was organized before the Civil War in the village of Union, originally under the name of Chandler and Rockwell. The bank failed, and closed its doors in 1885. Only 24 percent of the depositors' money was returned. All that remains today are a few of the lovely old checks. The bank was located on the site of what in now the Marine Midland Bank on West Main Street, Endicott.

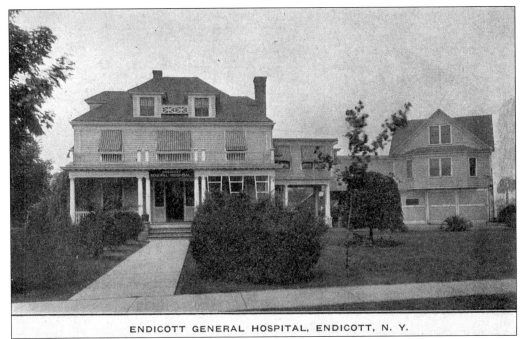

ENDICOTT GENERAL HOSPITAL, ENDICOTT, N. Y.

In 1915, Dr. Roger Mead began and operated a hospital on the south side of East Main Street. One year later he moved across the street in search of larger facilities. Fifty beds were available and were in use until the new Ideal Hospital opened. The home was demolished in 1988.

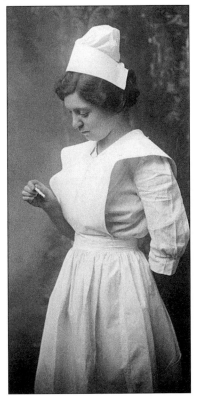

Nursing demanded professionalism, strength, dedication, and a starched uniform in the early 1900s.

In 1905, a hospital was established in a frame house donated by G. F. Johnson. The ten-bed hospital was located on Avenue A, and was known as the Kings' Daughters Hospital, in honor of the founding society. In 1911, Dr. Charles S. Wilson purchased the buildings at 47 Harrison Street and relocated the hospital, changing the name to Lestershire Hospital.

Ideal Hospital, Endicott, N. Y.

Ideal Hospital was built in 1927 on the side of Round Hill, in order to take full value from the healing powers of the view and sun. The land was donated by George F. Johnson, and within two years the building was completed, furnished, and considered one of the finest facilities of its kind in the state. It is currently the Ideal Senior Living Center.

The days of patent medicine took a long time to go out of fashion. Remedies were often touted on Washington Avenue, by professional hucksters offering the latest cures. These gentlemen were giving the public the opportunity to own an almost magical elixir in 1938.

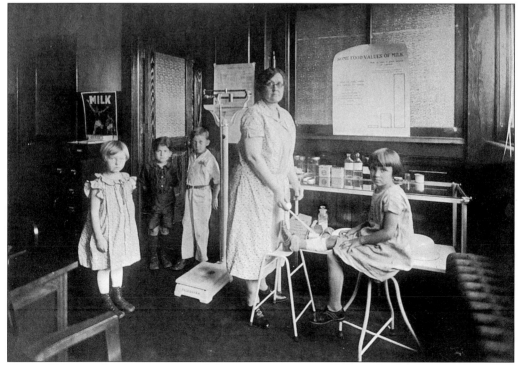

Town of Union schools were prepared for any emergency in 1929, with a first aid office in every facility, and a nurse on duty at all times.

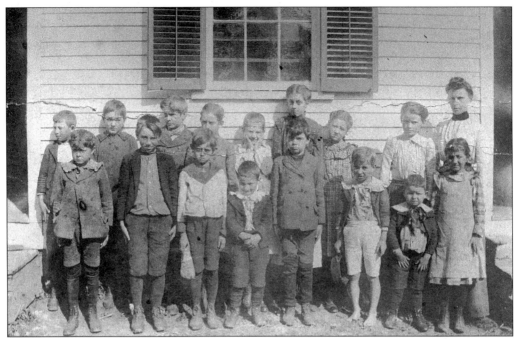

There were students of many ages, in one room, and shoes were optional at the Hooper School in 1901.

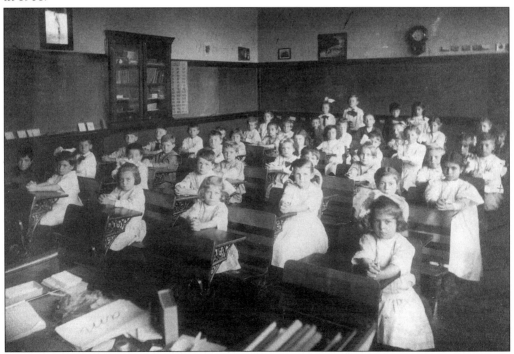

In 1912, teaching a class of approximately 50 students was not problem. Education was a privilege and appropriate behavior and respect for authority were the only mandates. Folded hands, learning by rote, prayers, and the Pledge of Allegiance were all part of the daily regime, before progress invaded the classroom.

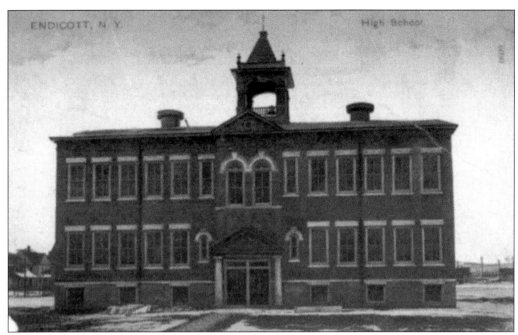

In 1906 when the Broad Street School in Endicott opened the position of principal offered a salary of $450 per year.

In June 1919, many schools in the area sprouted tubes from the inside walls to the outside, acting as a slide to safety for children during a fire. This girl is at the Broad Street School in Endicott using the escape during a fire drill. When store-bought bread wrapped in waxed paper came into style, students were encouraged to bring the empty wrappers to sit on as they slid to the ground—thus keeping the equipment slick and free of rust.

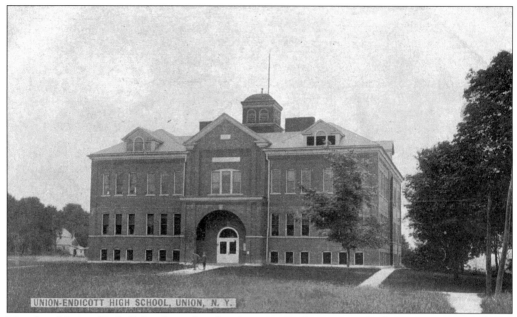

The first Union High School, on Loader Avenue, Endicott, NY, had the innovative idea of graded classes, with a room for each section.

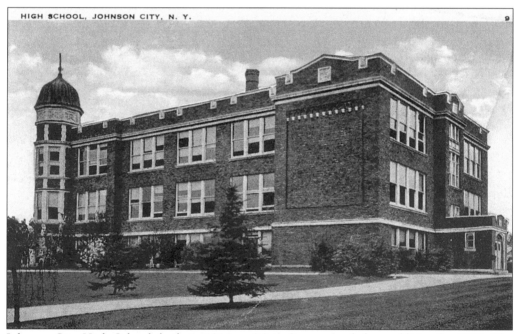

Johnson City High School, built in 1914 on Main Street, needed an addition by 1928. The building became almost symmetrical. The new wing was a window shorter than the older side. The structure is now the NYPEN Trade Center, an incubator for dozens of offices and small businesses.

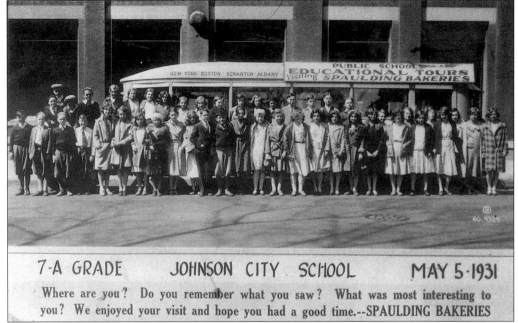

Spaulding Bakeries was glad to provide tours to local students in 1931. The Johnson City seventh grade had just completed a field trip when this photo was taken. Cards were sent to all the students as a memento of the visit.

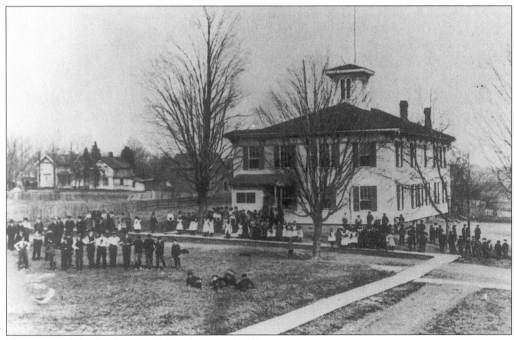

The original Loder Avenue School was in Endicott.

In the early 1900s, a major amusement park, White City, existed on Riverside Drive in Lestershire, New York. It boasted one of the largest roller coasters in the United States. For a while it was advertised as family entertainment. As time went on the area deteriorated and began attracting an unacceptable element of society. The problem accelerated to the point that a stone building on the premises was set aside for rowdy drunks, gamblers, and ladies of questionable morals.

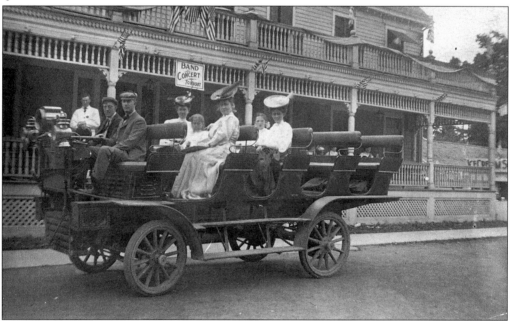

A special White City Bus made a day trip to the amusement park a convenient outing. It is hard to believe that Riverside Drive, now known for its stretch of lovely old mansions, was once known as a "corduroy road." The term refers to roads over land that were so swampy and rough that laying down a series of logs was the only way to make the terrain passable. The pathway resembled the welts of corduroy velvet, but in looks only. They were also known as Bumpy Bottom Roads.

John A. Davis Memorial Bible School, Bible School Park, N. Y.

Eventually, the land sold and became the home of the Practical Bible Training School, Inc. in 1911. It remains today a beautiful campus that brings grace to the banks of the Susquehanna.

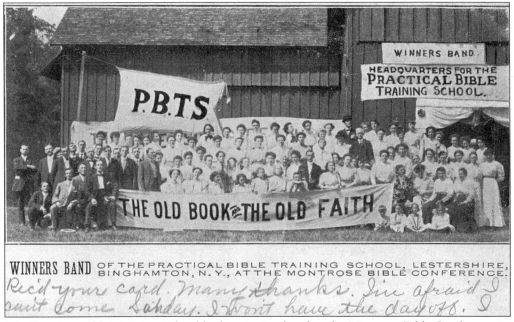

WINNERS BAND OF THE PRACTICAL BIBLE TRAINING SCHOOL, LESTERSHIRE, BINGHAMTON, N.Y., AT THE MONTROSE BIBLE CONFERENCE.

The Practical Bible Training School had a winning band at the Montrose Bible Conference in 1909. Several years before, the organization purchased White City Amusement Park and moved to Riverside Drive. The photo was made into postcards and sent to residents to encourage attendance.

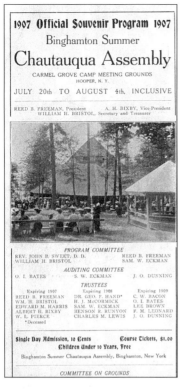

Founded by a group of Methodist ministers who accepted the idea of camp meetings to promote the word of God, Carmel Grove was opened in 1872. Revival gatherings were considered a worthy way to enjoy nature and renew the spirit during the summer months. In the winter months, it is said that enough fire and brimstone messages were delivered to keep the congregations warm even if the snow was deep. Located on 12 and one-half acres near what is now Hooper Road in Endwell, New York, the "City in the Woods" attracted thousands of people. At that time, the area was still rough roads and forests full of wildlife. The Grove was reached by taking a trolley as far as River Road, and then hiring a horse drawn carriage to complete the journey.

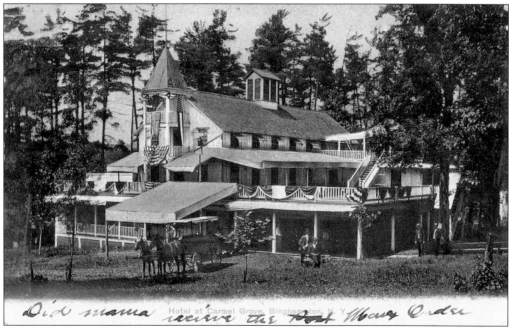

A modern three story-hotel was erected at the top of the hill, boasting acetylene lights. Tents and cabins fanned out over the hillside. On Sundays, the gates to the compound were closed and no one was allowed to enter or leave, to insure proper and uninterrupted reflections on faith.

This Song Book is from the Carmel Grove Assembly in 1903.

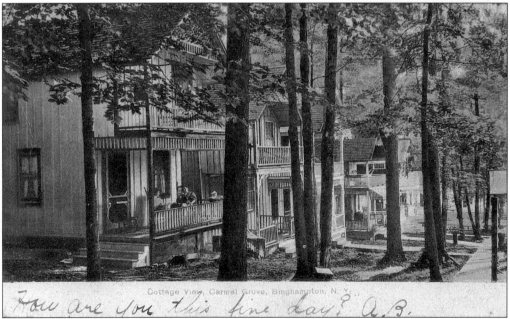

On a sunny June day in 1914, very unusual weather occurred. A cyclone completely devastated the campgrounds, and it was never rebuilt. Some of the remaining cottages, though damaged, were illegally claimed by squatters. Eventually the title to the land was cleared and it now contains a housing development.

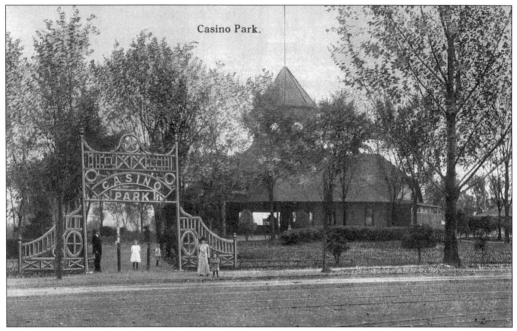

Casino Park.

At one time, Casino Park in the Town of Union, in what is now the village of Endicott, was a magnificent entertainment and social center. The park was developed to encourage the population to take day trips on the trolley. A racetrack, lush gardens, lagoons, delicate bridges, and a large community center bordered the Susquehanna River. Family entertainment, swimming pools, minstrel shows, boxing, and dances were just a few of the attractions. In the 1930s, it became Ideal Park, and later yet Enjoy Park.

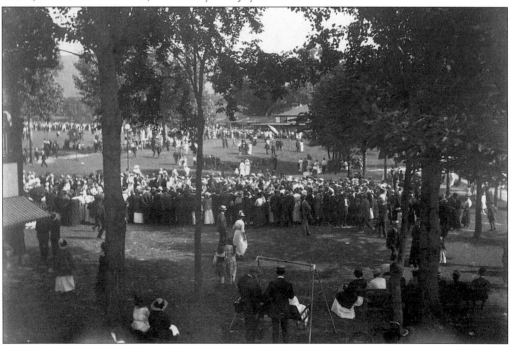

An ad in the *Union News* promotes Casino Park in the year 1900.

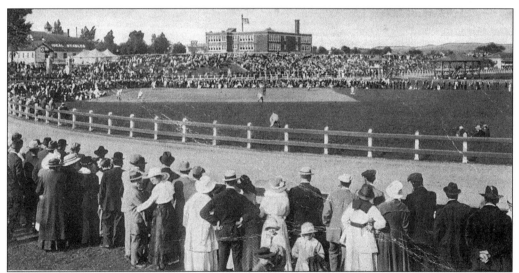

An Attractive Resort.
THE CASINO,
UNION.
A Delightful Trolley Ride,
Band Concerts,
High Class Entertainments.
SUNDAY CONCERTS
From 7:30 until 10:30
Fine Dancing Floor.
Special inducements to picnic and supper parties.
An Expert Caterer in Attendance.

In 1897, an interesting story appeared in the *Binghamton Chronicle*. As it has ever been, an all-male office party held yearly at the Casino was objected to by the "fair sex." The following is an excerpt from the report. "KLONDYKE CLAMBAKE CLUB FINDS CLAMS AND PEACE ON THE HOMEFRONT." Previous clambakes had been numerous, but a wail had gone up from the fair sex that although their lords and masters had had many a chance to feast, it had been their lot to stay at home on these festive afternoons. The resentment grew, so the enthusiastic managers of the affair, company husbands, and malcontent wives arranged a frolic to regain peace in every abode. The merry throng enjoyed good fellowship and unbounded hilarity. A varied program of vocal gems were sung. Strolling residents gazed open-mouthed at the brightly lit concert company on wheel. The occasion was such a joyful one that clambakes will not be as of yore, strictly stag events.

JOHNSON CITY AND ENDICOTT, N. Y.

MERRY-GO-ROUND, IDEAL PARK.

Four antique Herschell carousels are located in the Town of Union. George F. Johnson donated the unique treasures believing no one should be denied a few magical moments spinning through the mists of fantasy on a carousel. The G.F.J Park in Johnson City owns the largest carousel in the area. Seventy-two elaborately carved horses have spun through the summer days since 1923. G.W. Johnson Park on Oak hill in Endicott boasts a completely restored 1934 version of the "country fair" style merry-go-round. West Endicott Park on Page Avenue has been offering rides since 1929 on its 36-creature carousel. In addition, the only carousel of the group that has been relocated is now at Highland Park in Endwell. Originally installed in 1925 at En-Joie Park, it continues to attract people of all ages to its current hilltop site.

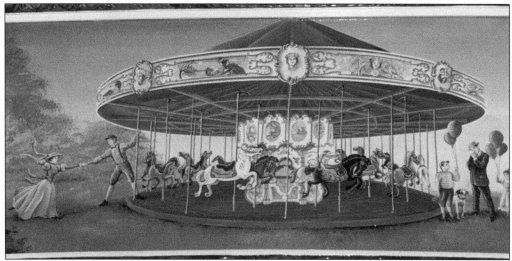

This photo is of a restored rounding board in the Oak Hill Avenue Park, Endicott.

These tennis courts, serving players in vest and hats, were located somewhere near the Lestershire Water Works.

Long skirts were still the required dress for women in 1911, even when playing tennis.

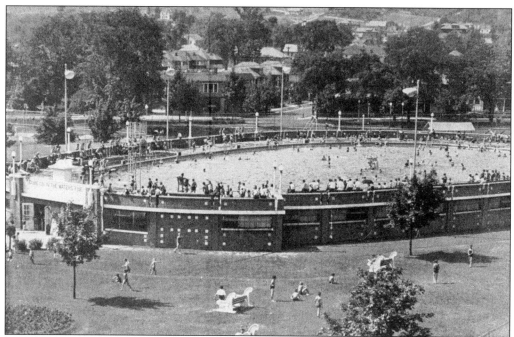

In 1924, the CFJ Recreation Park was built and equipped by the EJ Corporation. The elevated aboveground pool was one of the finest facilities in the state. Created from steel, concrete, and brick it would easily accommodate 2,500 swimmers. Water was obtained from an on-site artesian well. In 1966, the village of Johnson City purchased the park. By 1972, repairs were thought to be too extensive to preserve the landmark structure, and it was totally demolished.

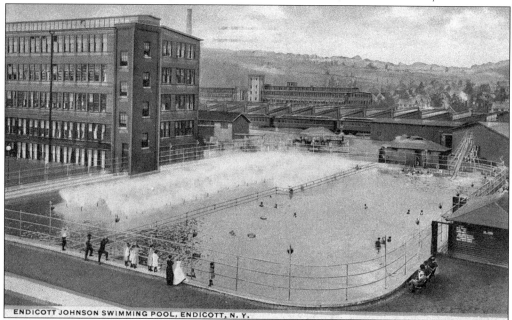

Right next to the Endicott Johnson factory on North Street in Endicott was located a large pool. It was situated very near the tannery, so even when swimming, residents were beset by the acid odors of chemicals and dyes. The site is now occupied by an IBM building.

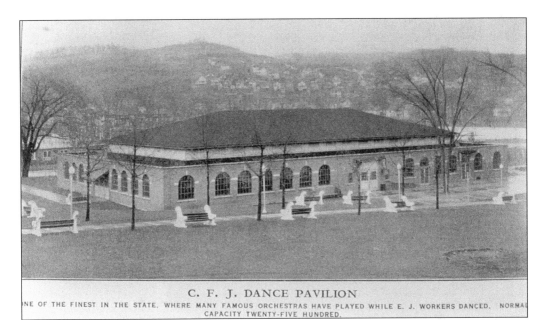

C. F. J. DANCE PAVILION
ONE OF THE FINEST IN THE STATE, WHERE MANY FAMOUS ORCHESTRAS HAVE PLAYED WHILE E. J. WORKERS DANCED. NORMAL CAPACITY TWENTY-FIVE HUNDRED.

The George F. Johnson Pavilion offered dancing from dusk to dawn in the era of the Big Bands. It was built in 1924 with an innovative canvass ceiling to make it impossible for the sound of music to bounce off walls and ceilings. The ordinary cost for dancing to local bands was an admission of 25 cents. When the well-known orchestras such as Glen Miller or Guy Lombardo played, the cost of a ticket was one dollar. All profits were given to charity. Over the years, it has provided generations with indoor entertainment, and at one time served as a roller skating rink. It now houses banquet facilities.

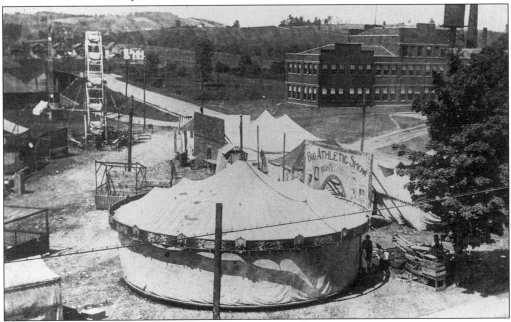

Entertainment in 1906 couldn't get much better than this traveling Carnival, set up on the corner of North Street and McKinley Avenue in Endicott. The Bundy building is in the background.

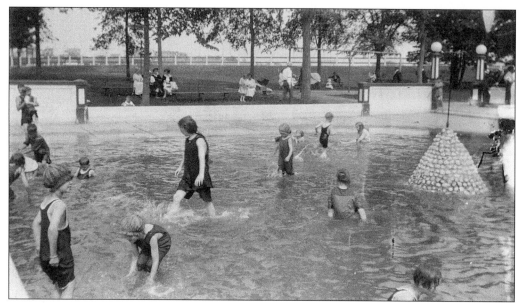

Swimming pools have always attracted children and fun. These children were enjoying the water in a small pool in Ideal Park.

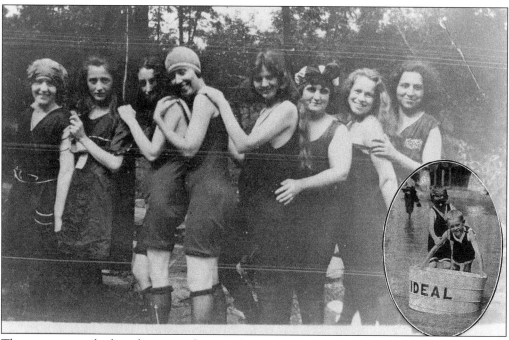

These were some bathing beauties of 1926. The small boys in the inset photo are "going to sea" in a refractory tub courtesy of the EJ factory.

John Gimmie was a boxing participant at the Endicott Athletic Association in the 1920s. He went on to become an Endicott fireman. The family name had been changed when they emigrated from Italy because people could not pronounce the name Cimeno.

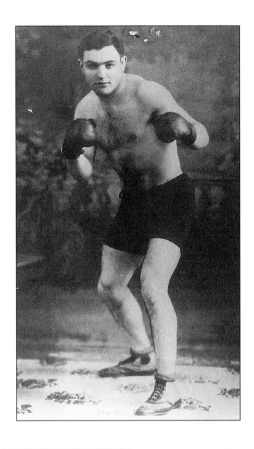

This photo of a lady on the course was taken in 1901 at the Broome County Golf Course, the original name of the Binghamton Country Club. Created in 1889, it is the oldest golf course in New York State. At the time of this photo, it was located on 15 acres between Main Street and the Susquehanna River, near what is now the hamlet of Endwell, NY.

This 1900 photograph taken in the Town of Union is probably not the boy's idea of what a ball player should look like.

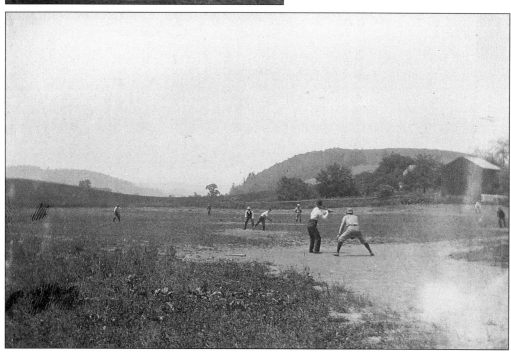

Sandlot ball was becoming the free time sport of choice, as these young men take over an empty space at the edge of town, c. 1900.

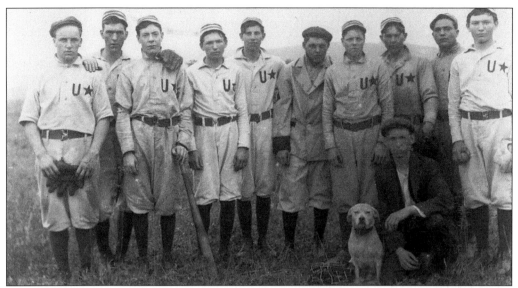

Union produced its own baseball team in the year 1907, including a mascot, and manager.

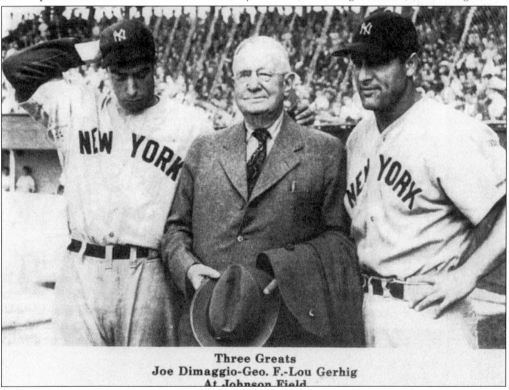

Three Greats
Joe Dimaggio-Geo. F.-Lou Gerhig
At Johnson Field

It was a Johnson family tradition to love baseball. From this desire to promote the sport came the creation of Johnson Field, home of Triplets baseball, a farm team for the New York Yankees. G. F. Johnson purchased the minor league franchise; built a playing field, and organized the "Knot Hole Gang," for children who could not afford a ticket. After several decades of providing a major sporting attraction for the area, the field was demolished to make room for the Route 17 expressway.

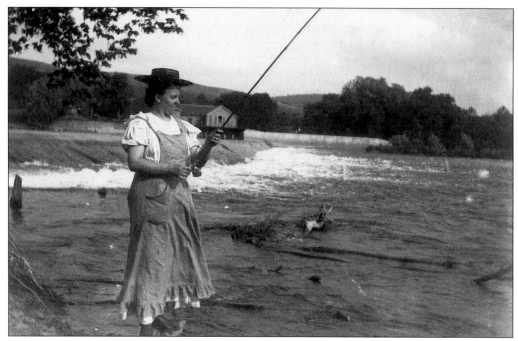

Fishing has been part of existence since the dawn of time. Prehistoric man, and biblical characters, and every generation before and since have used poles, hooks, clubs, crooks, and nets to capture the scaly morsels. Into the twentieth century, we are still fishing for substance, pleasure, and peace. In 1905, fishing in the Susquehanna River was being done by a lady of the family, and her image was preserved on a glass negative.

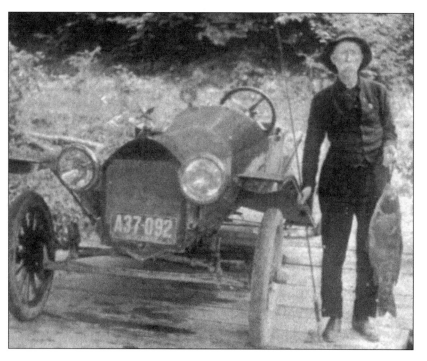

Often it is not the catch as much as it is the cunning used to obtain a fish that is important, but Mr. Hinsdale in 1919 was duly proud of his "largest of the day" fish.

Picnicking has always been a popular way to spend the day, cavorting, courting, and using the latest in telescopes, overlooking the growing Town of Union in 1905.

Camping has been called "getting back to nature with as many of the items of civilization as will fit in the automobile."

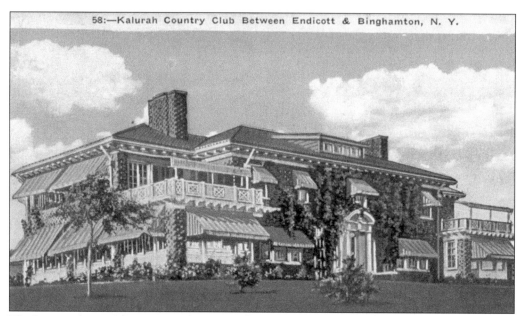

The large and graceful estate now known as the IBM Homestead was once the Kalurah Country Club, located near Watson Boulevard, in Endwell, NY.

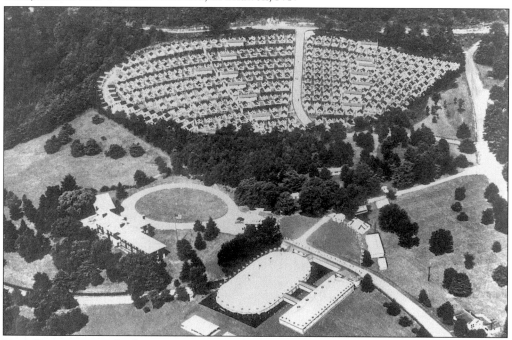

Tent City, an unusual sales convention, was located on the grounds of the IBM Homestead in the 1940s and 1950s. As a reward for meeting a yearly sales quota, members of the "100% Club" were given a week-long stay in two man tents on a hillside not far from the corporate birthplace. Each of the hundreds of tents was equipped with running water and a carpeted platform for the cots. Company pep rallies were held daily in a huge tent erected at the edge of the field. Two white shirts a day were required for men attending, so the corporate image of looking fresh at all times could be preserved.

IBM CLUB SONG BOOK

HAIL TO THE I. B. M.

Lift up our proud and loyal voices,
 Sing out in accents strong and true,
With hearts and hands to you devoted,
 And inspiration ever new,
Your ties of friendship cannot sever,
 Your glory time will never stem,
We will toast a name that lives forever,
 Hail to the I. B. M.

Our voices swell in admiration,
 Of T. J. Watson proudly sing,
He'll ever be our inspiration,
 To him our voices loudly ring.
The I. B. M. will sing the praises
 Of him who brought us world acclaim,
As the volume of our chorus raises
 Hail! To his honored name.

Before the reading of the annual reports, each day began with songs to inspire corporate loyalty. "Hail to Watson," and "Ever Onward IBM" were enthusiastically sung, as the new product lines for the following year were introduced. By October, a two-week stay on the hillside could produce quite a chill, but nothing could dampen the spirits of people recognized as the best in their field.

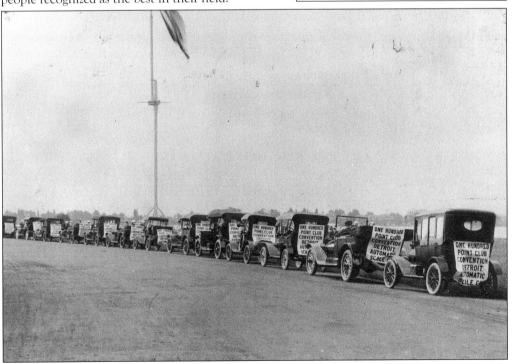

An earlier IBM Sales Convention, in 1916, had all the attendees motor to Detroit caravan-style in their salute to free enterprise.

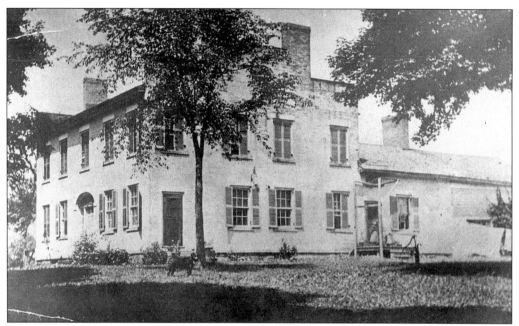

Ezekiel Crocker was one of the earliest pioneer settlers in the Town of Union. He built a large brick mansion on a slight rise in the valley land early in the 1800s. It was considered one of the finest residences in Broome County. In addition, it was a landmark inn where stage coach drivers looked forward to stopping, until about 1850 when stage travel declined. In 1857, the home burned to the ground, and was rebuilt close to the original style. IBM purchased the estate in 1931 and turned the 700-acre facility into an employee country club. Banquet rooms, bowling alleys, tennis courts, pools, and golf courses were made available at minimal cost to employees and their families. The site is now the Heritage Country Club, open to the public.

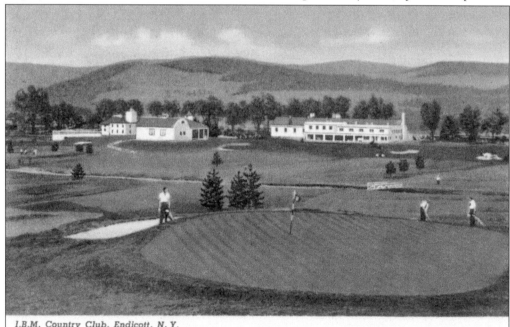

I.B.M. Country Club, Endicott, N.Y.

Good food was made available at reasonable prices in the IBM Country Club Cafeteria, even during the years of WW II, as this menu indicates. Alcohol was never allowed on the premises in accordance with the beliefs of Thomas J. Watson. Obvious intemperance at any time could be a reason for censure by the company.

MENU

SUNDAY DINNER
February 1, 1942 12:00 to 6:00

COMPLETE DINNER
35¢

Chilled Tomato Juice Cocktail

Southern Fried Chicken - Cranberry Sauce

Mashed Potatoes
 Green String Beans

Cottage Cheese Salad
Assorted Rolls - Butter

Choice of Beverages:
Coffee Chocolate Milk
Tea Butter Milk
Milk Orange Ade

Choice of Desserts:
Blueberry Pie
Butterscotch
Assorted Ice Creams:
Butterscotch Royal Maple Walnut
Butter Pecan Chocolate
Strawberry Vanilla

CHILDRENS SUGGESTIONS
Junior Portion of Regular Dinner 20¢
Special Vegetable Plate 10¢
Baby Food (Prepared to Order) . . 10¢

NO SUBSTITUTIONS ON COMPLETE DINNER EXCEPT AT EXTRA A LA CARTE PRICES

A LA CARTE DINNERS
(15 Minutes Preparation Time)

APPETIZERS
Chilled Fruit Cup 05¢
Tomato Juice Cocktail 05¢

DINNERS
BROILED FANCY CLUB LOIN STEAK, Mashed Potatoes, Salad, Choice of Vegetable, Rolls and Butter 50¢

POT ROAST OF BEEF, Gravy, Mashed Potatoes, Choice of Vegetable, Rolls and Butter 22¢

VEGETABLES
Buttered Beets 05¢
Green String Beans 05¢
Cottage Cheese Salad 05¢
Mashed Potatoes 05¢

DESSERTS
Red Cherry Cobbler 05¢
Blueberry Pie 05¢
Butterscotch Pudding 05¢
Ice Cream 05¢

BEVERAGES
05¢
Coffee Chocolate Milk
Tea Butter Milk
Milk Orangeade

BUY DEFENSE STAMPS

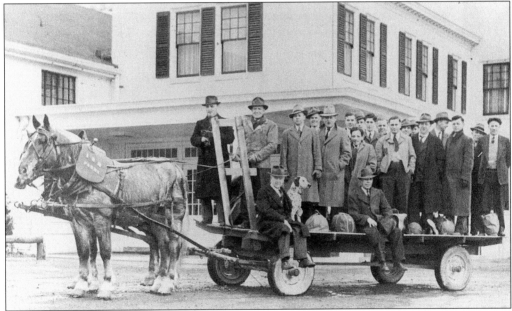

In 1942, during WW II, the gas shortage was so profound that this IBM bowling team traveled to a tournament by horse and wagon. The photo was taken near the IBM Country Club on Watson Boulevard. Steed and conveyance provided courtesy of the IBM Farms that grew much of the food used in the cafeterias.

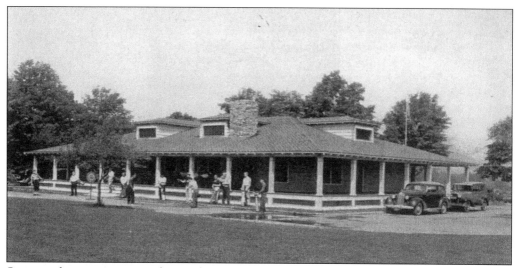

Sports and exercise are a vital part of any community, and G. F. Johnson promoted this ideal by creating the En-Joie Golf Course. Three hundred and fifty acres were set aside along the Susquehanna River west of Endicott. The village of Endicott now owns the club, which has become a world class course. Through the efforts of a golf course commission, under the leadership of Alex Alexander, and with volunteers from the whole community, the BC Open has obtained recognition as a major PGA tournament site. For more than a quarter of a century, the BC Open has been contributing to the local economy, and local charities, and becoming an acknowledged leader in the world of golf.

En-joie Health Golf Course. Clubhouse in right background; a few workers' homes in foreground

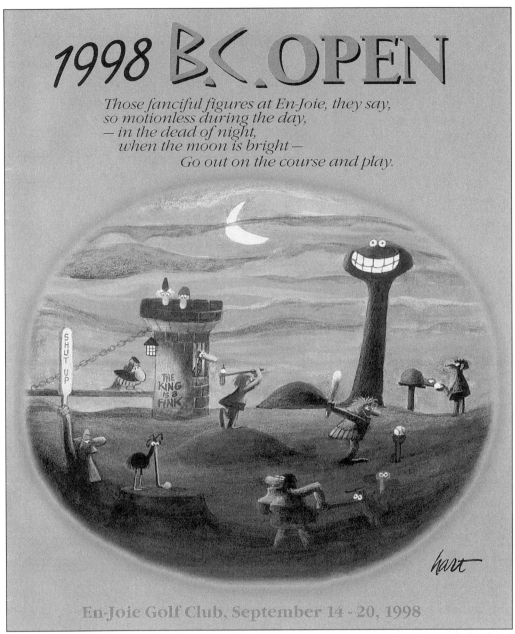

The BC Open has become synonymous with a pithy cartoon cave man who chats with God and plays golf. BC is found in the funny pages of national newspapers. Johnny Hart, the world famous cartoonist, generously donated the use of his character, BC, to promote the PGA golf tournament held each year in his hometown.

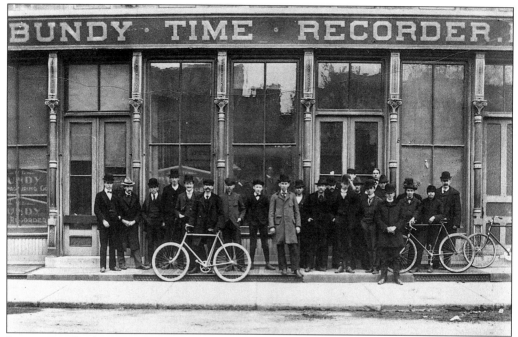

In 1888, Willard Bundy laid the foundation for one of the greatest technology corporations in the history of mankind—IBM. He devised a mechanical time recorder and opened a manufacturing plant in Binghamton, New York. In 1906, it relocated to Endicott, New York and changed its name to the International Time Recording Company (ITR).

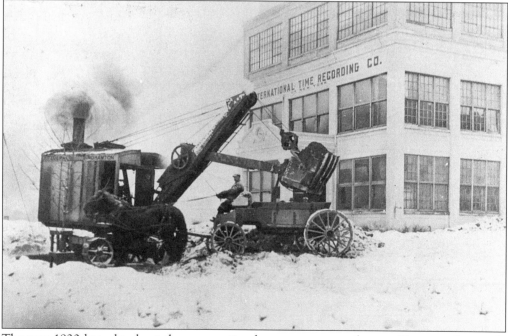

The year 1920 brought about the cooperation between steam and team. Horses and an early steam shovel work in front of the International Time Recording Company on North Street, in Endicott.

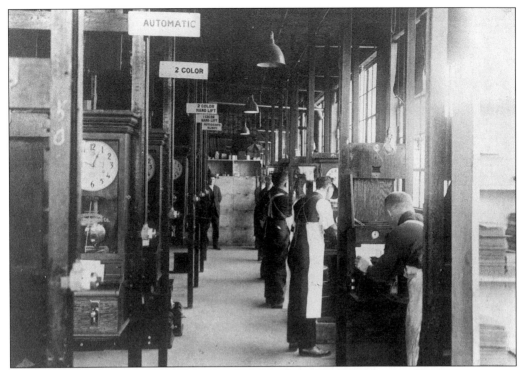
By 1916, time clocks were being mass-produced in the modern Endicott facilities.

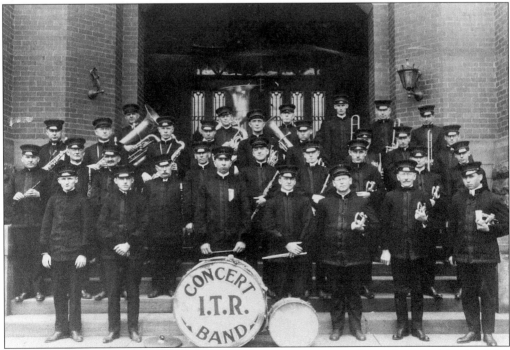
The ITR band played music in 1918 as part of a program to provide employees with a healthy, happy atmosphere. Weekly concerts on the lawn were attended and enjoyed both by workers at ITR and by members of the community.

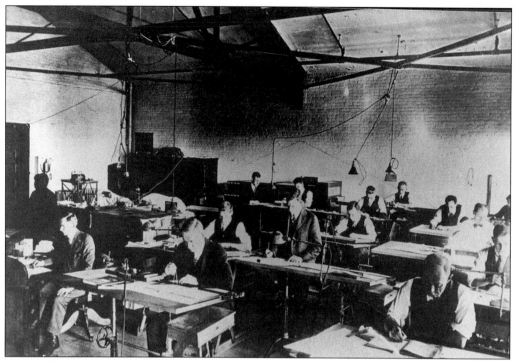

ITR (IBM) engineers are drafting the future in 1900.

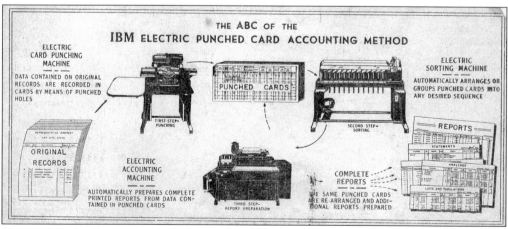

Computer technology was in its infancy when IBM was incorporated in the state of New York in 1911 as the Computing-Tabulating-Recording Company (CTR). An accurate method to compile and record statistics became a priority. Data was stored on punched cards. IBM trained some of the best minds available to service and repair the devices. The Town of Union became the birthplace of this great computer revolution.

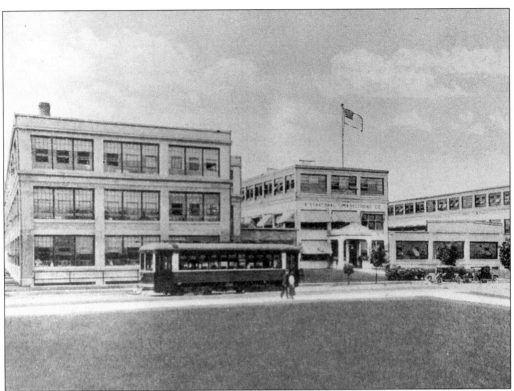

Thomas J. Watson joined CTR in 1914 and became the company president in 1915. Nine years later, the name of the corporation was changed to the International Business Machines. Building on a heritage of customer service, research, and development, IBM lead the computer age and eventually reaching into every area of human activity.

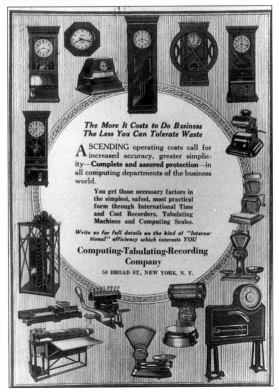

In 1920, IBM had a varied and impressive product line.

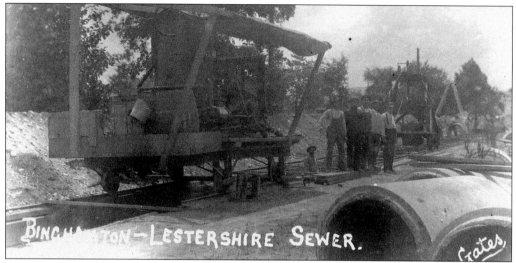

The unlimited pollution eventually became a problem. Contamination of wells by outhouses and animals too close to the well sites often led to typhoid, dysentery, and other ills. In 1913, Lestershire (Johnson City) and Binghamton set an example of municipal cooperation and agreed to build a joint sewer system.

Johnson City Water Department Pump House was built in the 1930s. This building could appropriately be titled "Recycle and Remember." It was constructed near the George F. Pavilion on Lester Avenue in Johnson City, and may have been one of the first major recycling efforts in the area—using odd-shaped stones retrieved from dismantled buildings, and other scraps from other sites. Imbedded in the exterior walls are a treasury of memories: an old fire extinguisher, rubber heels, old shoes, gears, pieces of chain, and even a pistol can be seen among the stones. This is a creative and lasting monument of industrial debris.

In 1904, the president with the "Big Stick" program in foreign policy, and a champion of the working man, ran for a second term. Theodore Roosevelt, the twenty-sixth president of the United States, and his running mate Charles W. Fairbanks had ardent supporters in Johnson City, as their banner across Main Street would indicate. Many local people agreed with the Roosevelt reforms regulating big business, and the conservation of natural resources.

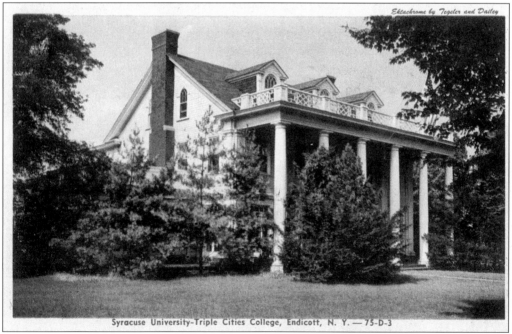

The pillared mansion named Colonial Hall was built in 1904 by Alphonses and Julia Ring Bowes. Throughout its long history, it has served as home for Syracuse University extension courses in 1932, as the Administration building for Triple Cities College in 1946, and Harpur College that is now part of the State of New York Campus in Binghamton. It has been restored to grandeur as the Endicott Visitor Center, heralding the western entrance to Broome County.

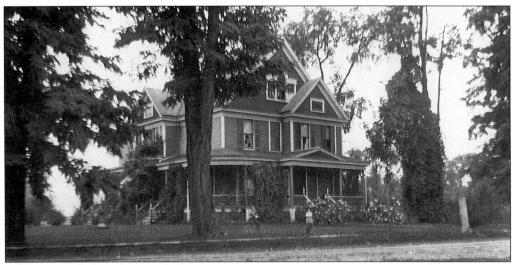

The Town of Vestal originated from the Town of Union in 1823. News reports of the day gave the following information: "…all parts of the town of Union lying south of the Susquehanna River…shall be known and distinguished as a separate town by the name of Vestal; and the first town meeting shall be held at the house of Jacob Rounds…as soon as may be we shall meet to divide the poor and money belonging to said town of Union…and each town shall forever thereafter support their own poor." By 1895, Fayette L. Rounds built this 15-room home directly across from Drovers Inn. Located at the corner of Bridge Street and Pumphouse Road, it is notable for the elegance and craftsmanship of another era. It is still owned and lived in by a Rounds descendant.

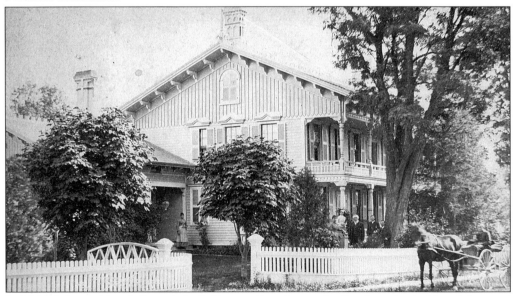

In 1844, John and Jacob Rounds built Drovers Inn. It was the first hostelry in Vestal. Located conveniently near the bridge connecting the two communities, it specialized in the drovers trade. The only way to market for the herds of sheep, cattle, and turkeys was to walk the roads to a large market. Special pens were constructed around the Inn for the livestock, so drovers could spend the night before continuing on their journey. The building still stands, restored, and again serving meals, this time as a fine restaurant.

These earnest students are attending a citizenship class at Your Home Library in the mid-1920s. Newcomers to the land were anxious to learn the ways of freedom, and ready to shoulder responsibility for their own welfare through hard work.

Immigrants to Union brought to their new homeland a symphony of talents and traditions that have blended with and enriched the local culture.

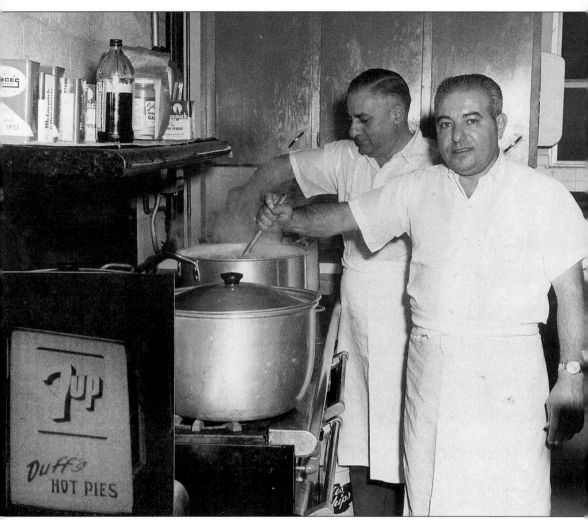

No book about the Town of Union would be complete without mention of some of the best food produced anywhere in the world. Excellent ethnic cuisine is available at many neighborhood restaurants, and some unique specialties originated locally. For many years there were prominent signs advertising a local delicacy, the Hot Pie. However, newcomers to the area often thought this to be a fruit pie warm from the oven, and made the mistake of eating dinner first, and then ordering a hot pie. Soon the signs changed to read the more commonly known term, Pizza. The above photograph shows Duff Consol creating a vat of pasta sauce in the 1940s, for one of the area's most popular Italian restaurants.

This is an outing for a group of IBM employees in 1950. Notice that the sign has changed to add the word 'Pizza.'

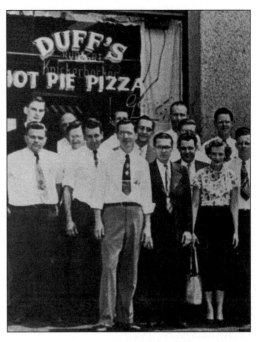

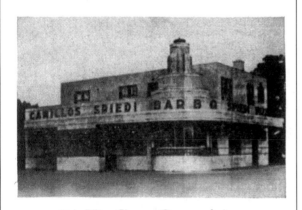

Endicott Daily Bulletin—Fri. Sept. 18, 1942

Our Most Sincere Congratulations
And Best Wishes To Our Friends in the
IBM Organization
On Their New Addition to the Endicott Plant

♦ ♦ ♦

We, Too, Have a New Building
And Are Proud it Is Located in Such
A Splendid Community

CAMILLO'S On the Geo. F. Highw
Just East of Endwell
Near Underpass to
IBM Country Club

The town of Union is the land of the *Spiedi*. Many Italian, and Arab, families claim to be the originators of this delicacy, and each recipe differs slightly, and deliciously. It is rumored that the first *spiedies* (there also many spellings of the word) were made from tender young goat meat marinated for a few days in secret spices and herbs before being skewered and grilled over hot coals. (This is not to be confused with a *shiesh-ka-bob*, made with meat and vegetables.) Some claim that lamb was the first *spiedie*, and others that it was derived from the pickled meat carried across the desert on the backs of camels, and the recipe brought to America by the Lebanese, and/or Italian immigrants. Wherever it came from, today you are apt to find the marinated morsels made from chicken, or pork, pulled from the hot skewer with the traditional piece of fresh Italian garlic bread. A local festival has been developed around the *spiedie* with hundreds of cooks vying for honors as the year's best *spiedie* chef.

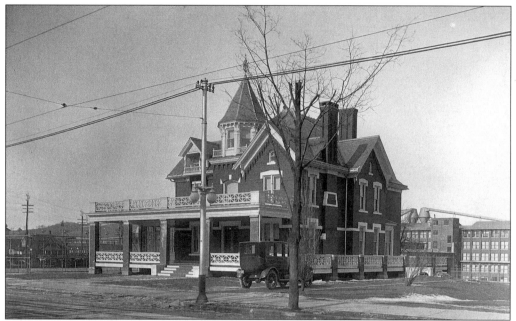

In 1885, Harry Brigham built an impressive home in Lestershire, New York, showcasing an American walnut staircase and detailed woodwork. In 1917, it became "Your Home Library." It was purchased by the Endicott Johnson Corporation under the guidance of Harry L. Johnson, who planned it to be both a library and a community center for EJ workers, and the community. It was enlarged in 1920, so the first floor could be used for the library, the second for social uses, and the third was reserved for a men's reading and smoking room. Over the years, it has housed classes in citizenship, sewing, cooking, language, hosted civic meetings, and scout units. Ownership has since passed to Johnson City, but it is still a vital part of the village, past and present.

This kitchen was located in Your Home Library, equipped with all the conveniences of home in 1918.

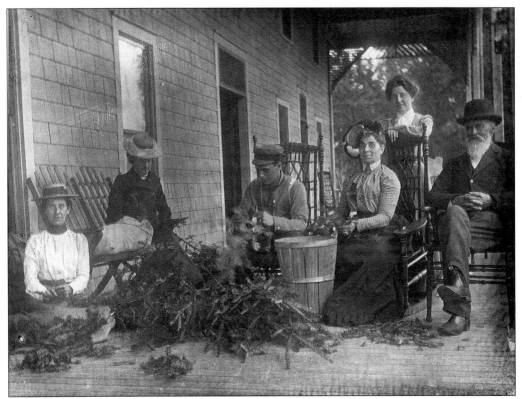

The end of the day often brought folks together to combine work with socializing, and called it a bee. After the Christmas season, evergreen boughs that had decorated homes were taken down and reused. The needles were stripped from branches and stored for use in pillows and sachets. This group is enjoying a traditional "Balsam Bee," about 1900.

BIBLIOGRAPHY

Seward, W.F. A History of Binghamton and Broome County New York. 1924.

Fiori, J. Town of Union—Between the Arches and Beyond 1990.

Ottman, Janet and Barb Vavra. Johnson City Centennial Book. 1992.

McGuire, Ross and Nancy Osterud, for Roberson Center for the Arts and Sciences. Working Lives—Broome County—1899–1930. Binghamton, NY.: 1980.

Combination Atlas Map of Broome County. 1876.

Bicentennial Committee of the League of Community Action. Our Heritage: Hooper Yesterday—Endwell Today. 1976. (Revised Edition by Claudia Baker, 1985.)

Lawyler, Wm. S. (Ed.) Binghamton and the Villages and Towns of Broome County and the Forces in its History—1800–1900. 1900.

Smith, H.P. (Ed.) History of Broome County New York With Illustrations—1885. 1885.

Unspecified. Partners All. Endicott Johnson: 1938.

Unspecified. EJ Workers Review. 1919, 1920.